6-WEEK DRAWING COURSE

A professional programme for artists

Barrington Barber

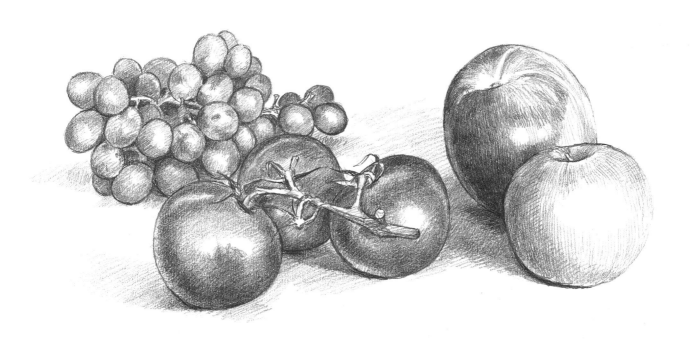

Arcturus

ARCTURUS

This edition published in 2015 by Arcturus Publishing Limited
26/27 Bickels Yard, 151–153 Bermondsey Street,
London SE1 3HA

Copyright © Arcturus Holdings Limited/Barrington Barber

ISBN: 978-1-78404-283-7
AD004283UK

Printed in China

Contents

Introduction

Learning to draw is not difficult – everybody learns to walk, talk, read and write at an early age, and discovering how to draw is easier than any of those processes! Drawing is merely making marks on paper which represent some visual experience. All it takes to draw effectively is the desire to do it, a little persistence, the ability to observe and a willingness to take time to correct any mistakes. This last point is very important as mistakes are not in themselves bad – they are opportunities for improvement, as long as you always put them right so that you will know what to do the next time.

Many of the exercises in this book incorporate the time-honoured methods practised by art students and professional artists. If these are followed diligently, they should bring about marked progress in your drawing skills. With consistent practice and regular repetition of the exercises, you should be able to draw competently and from there you will see your skills burgeon. Don't be put off by difficulties along the way, because they can be overcome with determination and a lot of practice and this means you are actively learning, even if it may seem a bit of a struggle at times. The main thing is to practise regularly and keep correcting your mistakes as you see them. Try not to become impatient with yourself, as the time you spend altering your drawings to improve them is time well spent.

Work with other students as often as you can, because this also helps your progress. Drawing may seem like a private exercise, but in fact it's a public one, because your drawings are for others to see and appreciate. Show your work to other people and listen to what they say; don't just accept or reject their praise or criticism, but check up on your work to see if they have seen something you haven't. If other people's views aren't very complimentary, don't take offence. Neither praise nor criticism matters except in so far as it helps you to see your work more objectively. Although at first a more experienced artist's views are of great value, eventually you have to become your own toughest critic, assessing exactly how a drawing has succeeded and how it has not worked.

Talk to professional artists about their work if you get the chance. Go to art shows and galleries to see what the 'competition' is like, be it from the old masters or your contemporaries. All this experience will help you to move your work in the right direction. Although working through this book will help you along your path to drawing well, it is up to you to notice your weaknesses and strengths, trying to correct the former and building on the latter.

Steady, hard work can accomplish more than talent by itself, so don't give up when you are feeling discouraged; drawing is a marvellously satisfying activity, even if you never get your work into the Royal Academy or the Tate Modern. Enjoy yourself!

Barrington Barber

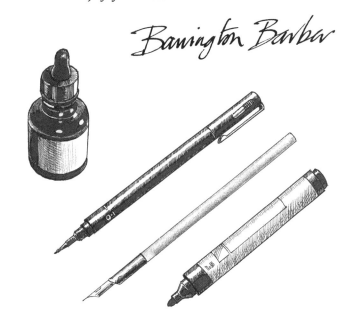

Materials and methods

Any medium is valid for drawing. That said, some mediums are more valid than others in particular circumstances, and in the main their suitability depends on what you are trying to achieve. Try to equip yourself with the best materials you can afford; quality does make a difference. You don't need to buy all the items listed below from the outset, and indeed it is probably wise to experiment gradually as you gain in confidence.

Start with the range of pencils suggested, and when you feel you would like to try something different, then do so. You can use any of the materials listed below to follow the projects in this book. Be aware that each material has its own identity, and you have to become acquainted with its individual facets before you can get the best out of it. However, once you are at ease with drawing in pencil, you will enjoy becoming more ambitious.

Pencil

The simplest and most universal tool of the artist is the humble pencil, which is very versatile. It ranges from very hard to very soft and black (H, HB, B, 2B, and so on) and there are differing thicknesses. Depending on the type you choose, pencil can be used very precisely and also very loosely.

You should equip yourself with at least three grades of pencil, such as an HB (average hardness and blackness), 2B (soft and black) and 4B (very soft and black).

Carbon pencil

This can give a very attractive, slightly unusual result, especially the dark brown (sepia), terracotta or sanguine versions. The black version is almost the same in appearance as charcoal (see p.6), but doesn't offer the same facility to erase it easily. If you are using this type, start off very lightly in case you make mistakes.

For working on a toned surface, you might like to try white carbon pencil.

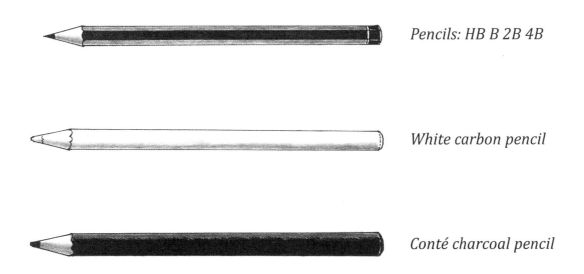

Pencils: HB B 2B 4B

White carbon pencil

Conté charcoal pencil

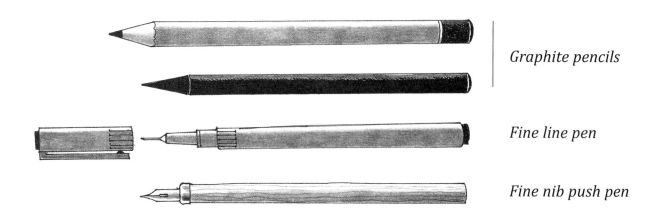

Graphite pencils

Fine line pen

Fine nib push pen

Graphite

Graphite pencils are thicker than ordinary pencils and come in an ordinary wooden casing or as solid graphite sticks with a thin plastic covering. The graphite in the plastic coating is thicker, more solid and lasts longer, but the wooden casing probably feels better to use. The solid stick is very versatile because of the breadth of the drawing edge, which enables you to draw a line 6mm (¼in) thick, or even thicker, and also very fine lines. Graphite also comes in various grades, from hard to very soft and black.

Charcoal

Charcoal pencils in black, grey and white are excellent when you need to produce three-dimensional images on toned paper and are less messy to use than sticks of willow charcoal and chalk. However, the sticks are more versatile because you can use the long edge as well as the point.

Drawings in this type of medium need 'fixing' to stop them being rubbed off the surface, but if they are carefully interleaved with pieces of paper they can be kept without smudging. Work that you wish to show for any length of time should be fixed with spray-can fixative.

Conté

Similar to compressed charcoal, conté crayon comes in different colours, different forms (stick or encased in wood like a pencil) and in grades from soft to hard. Like charcoal, it smudges easily but is much stronger in its effect and more difficult to remove.

Pen

Push-pens or dip-pens come with a fine pointed nib, either stiff or flexible, depending on what you wish to achieve. Modern fine-pointed graphic pens are easier to use and less messy but not so versatile, producing a line of unvarying thickness. Try both types.

The ink used for dip-pens is black 'Indian ink' or drawing ink; this can be permanent or water-soluble. The latter allows greater subtlety of tone.

Conté stick

Willow charcoal

Pastel

If you want to introduce colour into your drawings, pastels offer you plenty of choice. Dark colours give better tonal variation. Your choice of paper is essential to a good outcome with pastels. Don't use a paper that is too smooth, otherwise the deposit of pastel will not adhere to the paper properly. A tinted paper can be ideal, because it enables you to use light and dark tones to bring an extra dimension to your drawing.

White chalk

This is a cheaper and longer-lasting alternative to white conté or white pastel.

White chalk

Pastel

No. 6 sable brush

No. 2 nylon brush

Scraper-board tool

Brush

Drawing with a brush will give a greater variety of tonal possibilities to your drawing. A fine tip is not easy to use initially, and you will need to practise if you are to get a good result with it. Use a soluble ink, which will give you a range of attractive tones.

A number 0 or number 2 nylon brush is satisfactory for drawing. For applying washes of tone, a number 6 or number 10 brush in sablette, sable or any other material capable of producing a good point is recommended.

Paper and board

Any decent smooth cartridge paper is suitable for drawing. A rougher surface gives a more broken line and greater texture. Try out as many different papers as you can.

You will find a good-quality cartridge paper most useful. Choose one that is not too smooth; 160 gsm (98 lb) weight is about right. If you are unsure, ask in your local art or craft shop, where they will stock all the materials you require.

Drawing in ink can be done on smooth paper, but even here a textured paper can give a livelier result in the drawing. For drawing with a brush, you will need a paper that will not buckle when wet, such as watercolour paper. For pastels, you will find a good range of toned and textured papers.

Scraperboard

Scraperboard has a layer of china clay which is thick enough to allow dry paint or ink to be scraped off but thin enough not to crack off. It comes in black and white. White scraperboard is the more versatile of the two, and allows the ink to be scraped with a sharp point or edge when it is dry to produce interesting textures or lines. The black version has a thin layer of black ink printed evenly over the whole surface which can be scraped away to produce a reverse drawing resembling a woodcut or engraving. Try them out. Cut your first piece of board into smaller pieces so that you can experiment with a range of different approaches.

The tools you need to work effectively with scraperboard can be obtained at any good art or craft shop.

Eraser

The best all-purpose eraser for the artist is a putty eraser. Kneadable, it can be formed into a point or edge to rub out all forms of pencil. Unlike the conventional eraser it does not leave small deposits on the paper. However, a standard soft eraser is quite useful as well, because you can work over marks with it more vigorously than you can with a putty eraser.

Drawing ink

Most artists try to use an eraser as little as possible, and in fact it only really comes into its own when you are drawing for publication, which requires that you get rid of superfluous lines.

Normally you can safely ignore erasers in the knowledge that inaccurate lines will be drawn over and thus passed over by the eye, which will see and follow the corrected lines.

Stump

A stump is a tightly concentrated roll of absorbent paper formed into a fat pencil-like shape. Artists use it to smudge pencil, pastel or charcoal and thus smooth out shading they have applied, and graduate it more finely.

Sharpener

A craft knife is more flexible in its use than an all-purpose sharpener and will be able to cope with any medium. It goes without saying that you should use such an implement with care and not leave the blade exposed where it may cause harm.

First steps in drawing

This part of the book starts with a series of straightforward exercises that will help you to tackle the process of drawing if you're a complete beginner. Even if you're a competent draughtsman it's wise to carry them out because the repetition of mark-making such as this helps you to get the feel of your tools and bring your eye and hand into cohesion.

The exercises may look very simple and indeed most of them are, but if you're a beginner don't be tempted to think they are so easy that you may as well skip them and rush straight on to drawing subjects that appeal to you. By doing that you may be very disappointed with your results, and that's a disheartening way to start – you may even decide that you have no talent at all. In fact, learning to draw is just a matter of making the same marks over and over again until you get them right, with increasing ease and fluency. So it's much better to spend some time developing a steady line with your pencil, practising your ability to follow simple shapes and apply tone, so you start on 'real' drawings with some confidence under your belt.

Once you've developed control of your pencil you can begin to look at everyday objects around the house in the following chapters. I don't guarantee to turn you into an artistic genius, but with a little effort and the will to persevere you'll soon develop your abilities.

Simple marks

Before we make a start on drawing objects from the real world, it's a good idea to practise some simple exercises as a warm-up. While these first pages are primarily intended for beginners, you'll find that the exercises are still useful even if you've had a good deal of practice.

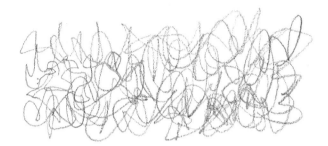

1 To make a start, try drawing a wavering, continuous line that repeatedly overlaps itself. As you draw, note the effect of the pencil on the surface of the paper. This first exercise is really just to encourage you to realize that the feel of your materials is just as important as the visual result. Without this understanding you'll find that your drawing lacks tactile values.

2 When you feel you have pursued your scribble for long enough, try out a simple sequence of repetitive strokes of vertical lines drawn so close together that they start to look like a patch of tone.

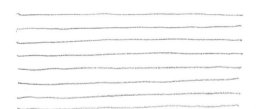

3 Then try some horizontal lines that are more spaced out and are all about the same length, the same distance apart and as straight as you can make them. You are now beginning to control your pencil to achieve an effect.

4 Now try drawing a spiral that starts on the outside edge and moves slowly inwards until you reach the centre. Then do the opposite, starting in the centre and spiralling outwards.

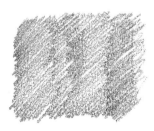

5 Next lay down a whole rectangle of medium to dark tone, moving the pencil in diagonal strokes as naturally as your hand can manage and always in the same direction. Try to keep the tone the same all over.

6 Make a layer of vertical strokes close together, followed by a layer of horizontals going across them, then by diagonals crossing in both directions. As you can see, this builds up a dark tone.

8 Draw several small circles, lining them up in rows of four or five. The idea is to make them as similar as possible and all in regular formation. You are now dividing up space and organizing shapes.

7 Now try drawing a circle as perfectly as you can. Then imagine a perfect circle in your mind and try drawing a circle again. This is not so easy as the previous exercises but is very good practice.

9 Next comes a series of simple conceptual shapes, starting with an equilateral triangle – that is, one with all sides equal.

10 Now try a square, remembering that all sides should be the same length and all corners are right angles (90 degrees).

11 Now draw the same shape but tilted up so that it stands on one corner – slightly more tricky to do.

12 Without taking your pencil off the paper, draw a five-pointed star. This may need a few attempts before you get it right.

15 Now draw a crescent moon shape, which is only parts of two circles overlapping.

13 Now draw two equilateral triangles overlapping to make a six-pointed star.

14 And after that, two squares overlapping to make an eight-pointed star.

11

The next step is to concentrate more on tone in order
to draw apparently three-dimensional shapes.

1 To start with, draw some shading, using vertical strokes that gradually get lighter until they disappear altogether.

2 Now draw a circle and shade in around the outer rim, graduating the tone lighter and lighter as you approach the centre. As you can see, this resembles a sphere.

 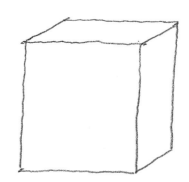

3 Draw a square, then draw three parallel lines from three of the corners, as shown. Draw two more lines parallel to the edge of the square. What appears before your eyes is a conventional representation of a cube shape – a three-dimensional object.

 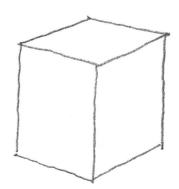

4 A way to do a similar figure is to draw a flattened diamond shape, extend three verticals from the corners and then join their ends to make another cube.

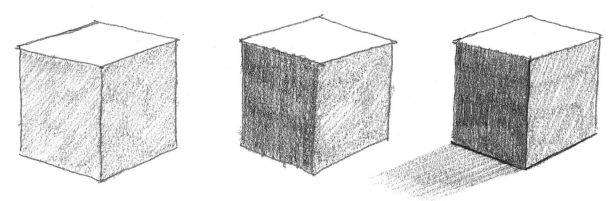

5 Give this last figure a three-dimensional quality by shading in the two lower surfaces of the cube with an even tone – not too dark. Then work over the left-hand surface with a slightly darker tone. Draw in a cast shadow stretching away from the darker side of the cube. All this has the effect of making the cube look even more solid.

6 The next exercise is to draw some ellipses, which are curved shapes that resemble a circle seen from an oblique angle. If you look at a wine glass, the top edge and the base will appear to be ellipses unless you are viewing it from immediately above. Draw several of these to get the idea, remembering that the curve must be continuous, without any flattened bits or pointed ends. Depict some of them on their narrow ends so that they resemble a wheel seen from an angle.

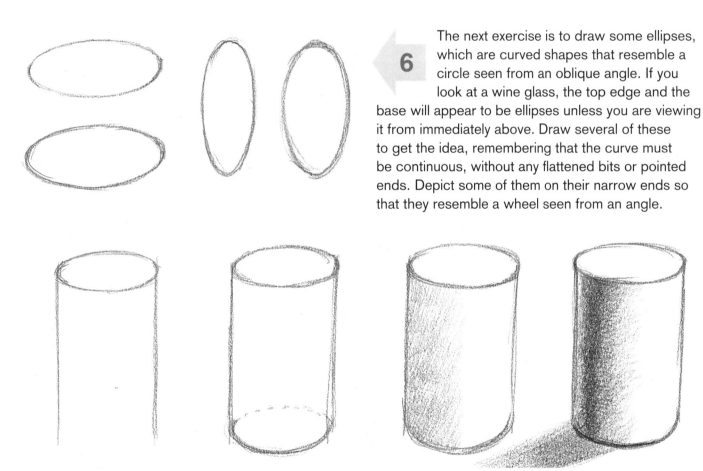

7 You can now use your ellipse-drawing skill to depict a cylinder. Draw the ellipse, then project two vertical lines downwards from the narrow edges. Draw a second ellipse at the lower end of the two straight lines. To make the cylinder appear solid, rub out the top edge of this ellipse.

When you've done that, shade very lightly down the left-hand side of the cylinder, allowing the tone to fade off to nothing about halfway across the length. Darken a strip down the left-hand side of this shadow, not quite touching the side of the cylinder. Finally, put in a cast shadow as you did with the cube.

Simple drawings

Let's look now at some patterns that have their origin in nature. These are all doodles again, but more formal; they are representative of what you might see growing in the countryside or in your garden.

Exercise 1

For the first shape, make a small circle with five small lines coming out from it, then draw petal shapes around the outside of the lines. The result looks like a flower.

The next one is similar in design, but the petals are more pointed at the tip and there are six of them this time.

Draw a small circle then put elongated petals around it, one at the top, one opposite at the bottom and one each side to form a cross. Fill in with four diagonal petals. In the spaces between, draw partially visible petals, followed by an outer set.

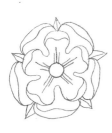

To draw a Tudor rose, start again with a circle, then put in five sets of small lines radiating from it. Around this, draw a five-petalled rose shape with overlapping edges, then put a small leaf shape projecting from the centre of each petal. Then draw in the last set of petal shapes in between each leaf.

The last flower shape is a bit like a chrysanthemum, with multiple long, thin, pointed petals radiating from a central point.

Next we go on to plant-like shapes with a central stalk. These drawings will help you to get a feel for the way in which natural growth proceeds. The first is just a straight stalk with a leaf shape on the end and additional stalks growing out of the central one, each bearing a leaf. Make the middle leaves larger and the bottom leaves smaller.

In the next drawing there is again a straight stalk, but the branches are all curling. Keep the twigs at the top and bottom simple and allow the middle layers to be more complex. Notice how some curl one way and some the other. Play around and experiment.

Here the stalk is drawn more substantially, thickest at the base and tapering to a point at the top. Draw the lower branches also with a bit of thickness and allow small, straight twigs to branch off in all directions. Try to maintain the same growth pattern all over the plant.

The last drawing is a similar growth pattern, but this time all the branches and twigs are curly. Start with the central trunk and add the thicker branches first before putting in the smaller ones. Have fun and be inventive.

Exercise 2

Now we move on to the human head, hand and foot. Like the plant forms, these are diagrammatic drawings, but they give you a good idea of the shape and proportion of the human head and extremities.

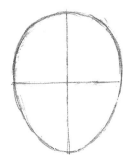

Start by drawing an oval like an egg perched on its smaller end, then divide it halfway both vertically and horizontally.

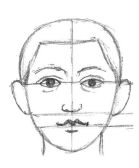

When the head is upright and facing you directly the eyes are halfway down. On the average face, the end of the nose is halfway between the eyes and the bottom of the chin. The mouth is about one-third nearer the nose than the bottom of the chin. There is about one eye length between the eyes, and also between the outer corner of the eye and the outer side of the head.

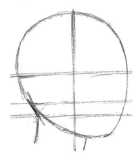

From the side, the head is as wide as long. Divide as before, placing the ear behind the halfway vertical.

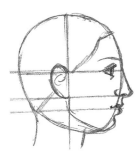

Project the nose, mouth and chin beyond the oval. The length of the ear is from about the eyebrow down to the bottom of the nose. Notice the shape of the eye seen from the side.

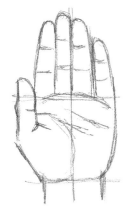

The hand is a simple block shape, with the palm almost square and the fingers about the same length as the palm. Draw a central line and this will be where the fingers divide two and two. They tend to taper a little towards the top, and the middle finger is usually the longest, with the forefinger or third finger coming next, then the little finger.

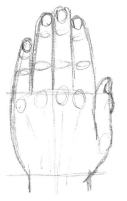

The thumb is usually a little shorter than the little finger, but appears much more so because it starts lower down the hand. Check with your own hand, noticing the knuckles on the back and the padded fleshy parts on the palm.

The foot is simpler, especially when seen from the side. Notice how the toes curve and how they tend to be progressively shorter from the big toe to the little one. Some people have the second toe longer than the big toe, but this is variable.

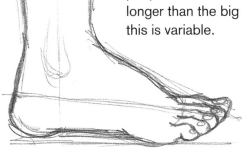

Tone and hatching

Here are a few exercises to sharpen up your techniques before you leap into the next project. Since drawing an interior will entail covering larger spaces with tone, these exercises are intended to give you dexterity in hatching and shading to produce varying degrees of tone. I have concentrated on pencil and pen and ink exercises this time. The three items that you will need to do these exercises are: a soft dark pencil (4B), a fine-pointed graphic pen and a rolled paper stump to smudge some of the pencil marks.

1 Make marks by rubbing the side of the pencil lead against the paper.

2 Make lines all at one angle to produce an overall tone of grey.

3 Draw verticals and horizontals crossing over each other to produce an even tone.

4 Next draw horizontals, verticals and diagonals in both directions to produce a darker tone.

5 Make marks in all directions until a dark cloud of tone is produced.

6 Now try some pen and ink marks, the first one lots of tiny strokes to produce a dark texture.

7 As with the pencil marks, draw them all in one direction.

8 Then draw verticals, all about the same length and the same distance apart.

9 Add some horizontals on top of the verticals, similarly equal in length and spacing.

10 Lay some diagonals in one direction over the verticals and horizontals.

11 Then put in more diagonals in the opposing direction over the last three sets of lines.

12 With your pencil, produce a very dark area and gradually soften it to become lighter, fading it out to nothing with the stump.

Week 1

Starting out with still life

Now that you have had some practice at line drawing and showing areas of tone, the next easy step is to test your skill at drawing some simple objects.

Once you begin trying to describe forms rather than just doing exercises such as the ones on the previous pages you have to use your powers of observation too, which is not as easy as it sounds. You have to really look at your subject and put aside preconceived ideas of its shape and texture, because these will probably not be accurate.

For instance, if you tried to draw a particular chair entirely from memory you might expect to get things wrong. But when you draw a chair you can see, unless you look at it really carefully, you will probably still make mistakes because you will be working partly from memory without realizing it. So you need to make a conscious effort to draw only what you see.

In this section I have shown a variety of objects that you may have in your house, but you can choose any subject that interests you. This stage will give you practice in drawing various shapes and textures before you tackle more complex objects and then whole compositions. The main thing is to enjoy the process of drawing without worrying about how well or badly you're doing; just keep observing and recording what you see, and you'll find that the more you do this the better you will get.

Drawing simple objects

The still-life genre has been popular with artists over many centuries, and while you will see masterworks of the greatest skill and complexity it's also a genre that lends itself well to simplicity and spareness. From the point of view of a novice artist, drawing still lifes is an excellent way to begin making pictures, since most elements of a still life will remain unchanged in the chosen arrangement for as long as they are needed; it's only when you include flowers and other plants that the question of movement and decay is introduced.

Two milk jugs

Here I have chosen a couple of milk jugs and set them on the table, the smaller jug overlapping the larger one. To start with I drew simple but precise outlines – it's important at this stage to get the shape as exact as possible. Draw your own lines very lightly, so they can be corrected easily.

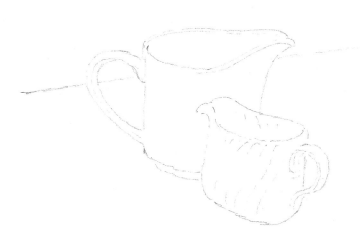

Next put in the tonal areas as I have done, all in one tone, regardless of whether the actual tone is dark or light. This gives you the feeling of the substance of the objects and allows you to see how much further you can build up definition in them. Keep the tone as light as possible – only as strong as the lightest tone visible.

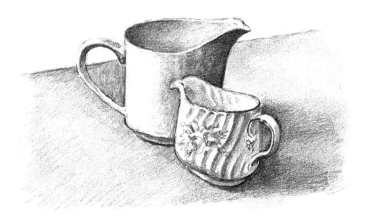

Now you can build tone to create darker areas, which will give the impression of solid three-dimensional shapes. Don't hurry this stage – it's better to reveal the substance of the objects gradually in order to avoid over-darkening the tones. There are some very dark tones, but they represent only a small part of the whole.

Coffee-maker

This coffee-maker seemed like a good subject for a simple still-life drawing. It is glass, so you can see the whole shape fairly easily, but the structural framework makes it a bit more complex than the jugs. You will need to study it attentively to get all the bits in the right position and proportion, but it's very clearly defined, so you will be able to see quite easily whether your drawing is accurate or not.

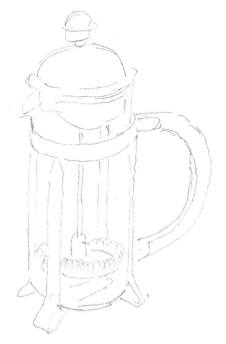

I started with a simply drawn outline of everything that I could see, without concerning myself as to the definition of the lines that I drew. At this stage, keep your own lines light and not too definite.

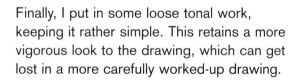

Then I started to put in more definite marks, showing the darkest and most dramatic lines of the structure. Don't begin to do this until you are satisfied with the previous stage, where you can erase any mistakes and correct them easily. Note that the lines of the metal framework and the plastic handle and lid are more strongly marked than the glass.

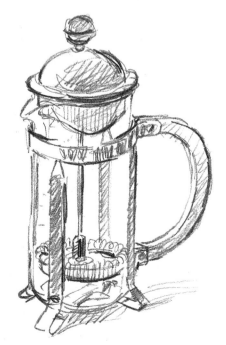

Finally, I put in some loose tonal work, keeping it rather simple. This retains a more vigorous look to the drawing, which can get lost in a more carefully worked-up drawing.

Colander and shells

I drew this still life in ink, using a fine line pen, and encourage you to do the same so that you no longer have the ability to correct your mistakes easily. This is a brilliant exercise for concentrating your mind on what marks you will actually put down on the paper. If you don't always get things right that's no great problem – you can always start again on a fresh sheet of paper.

Here the still life is a metal colander and a couple of seashells, which looks simple enough, but both objects are quite challenging to draw because of the metallic reflections on the colander and the striations on the shells.

Step 1

As usual, I drew a simple outline first, lightly and loosely. As you cannot erase any mistakes this time, look carefully at the objects before you make your marks.

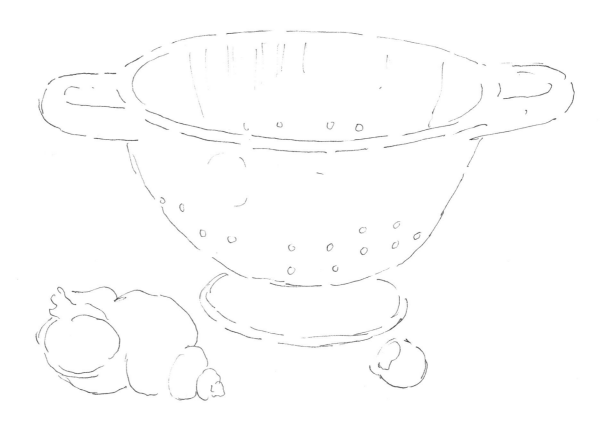

Step 2

The next stage is to put in the main tonal areas, as usual. Make a very light pattern of lines, avoiding any parts where there are highlights. You can also put in a few of the darkest marks that you can see with a thicker pen line, but they should be very minimal.

Step 3

Lastly, returning to the thinner pen, draw in as many lines as are necessary to build up the tonal values, until your objects resemble the ones shown here. Notice how some areas of dark can be worked over with lines going in all directions, to build up the density of tone. If you think one or two areas need thicker pen lines to give a blacker mark, use them, but don't overdo it. The complexity of the reflections in the metal surface will give you some cause to look very carefully at how to make that work. The striations on the shells are also tricky, because you don't want to make them too strong, which would break up the surface too much.

A still life of fruit

Next, try a small group of objects. Collect a few pieces of fruit that appeal to you and arrange them on a surface so that some of them are behind others. I've chosen a bunch of grapes, which I've placed further back than the rest of the fruit, and three tomatoes, an apple and a nectarine.

Start off by making a very loose sketch to get some idea as to how the arrangement looks. This drawing is not precise and is really to give you a basis on which to start drawing more definitely.

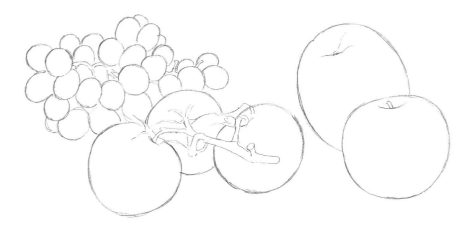

In the next stage, draw the shapes of each piece of fruit quite concisely, making sure that each is as accurate as possible. This is the time to do any correcting and erasing, with the hope that it won't then be necessary in any later stages.

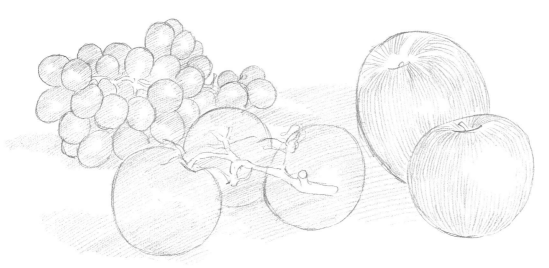

Then carefully put in the areas of tone, all in a uniformly light tone. With the larger pieces of fruit, draw the tonal area with your pencil strokes following the form of the fruit.

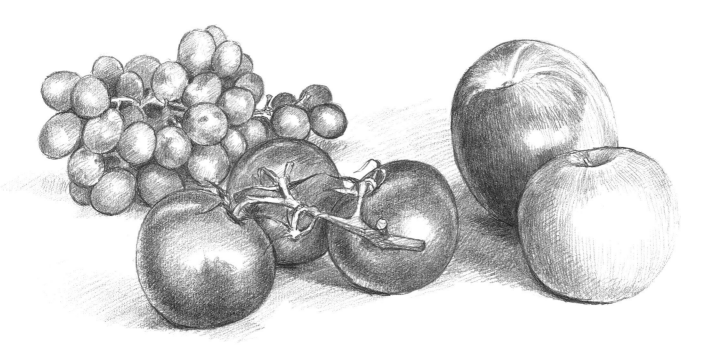

Now all that is needed is to work over all the tonal areas until the darkest to lightest values make sense. One way to see how correct your tonal values are is to half-close your eyes when you look at the still life, which will help you to see tone rather than colour. If you have taken the tone over the highlighted areas by mistake, you can bring those back by using an eraser to re-establish them.

Simple still lifes

It isn't difficult to put together a still-life arrangement, but it does require some thought and aesthetic appreciation. If you are a beginner, it's a good idea to accumulate your still-life objects gradually, with some feeling of how the final shape of the arrangement will look. I began the exercise by simply choosing things that make interesting drawing problems for an artist to solve.

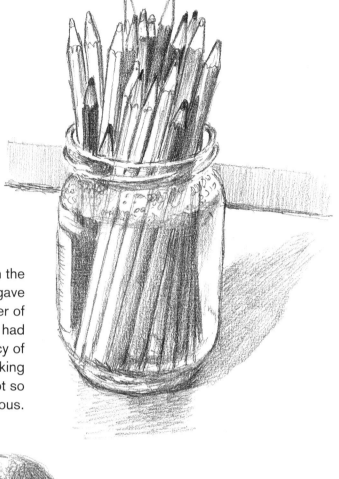

Starting with what happened to be on the top of the plan chest in my studio, I gave myself the problem of drawing a number of pencils bunched together in a glass jar. I had to find a way of showing the transparency of the pot and the variety of pencil tops poking up out of it – slightly difficult, but not so much that it would become laborious.

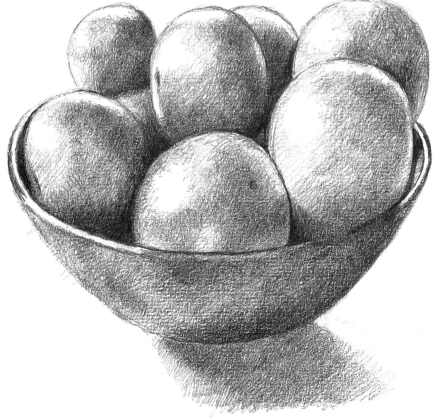

Next I took a bowl of oranges that was on my dresser. Fruit in a bowl is a traditional prop for still-life arrangements and presents the problem of drawing spherical objects that are pushed together by the sides of the bowl. Both of these subjects are the kind of thing that make a simple still life without any other objects being necessary; of course you might want a bit more background space to show off the quality of your drawing, but nothing else is particularly needed.

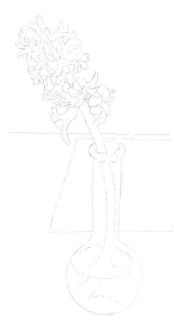

I then drew a glass vase with one stalk of flowers in it. This is both simple and complex, because while there is only one flower and one vase, the latter is glass, which can be difficult to draw convincingly, and the flower is a composite stalk of many small blossoms. There are two stages to portraying the subject – first the simple outline of the shape, which you may need to correct a bit, and then the building up of tonal values so that the finished article looks as though it exists in its own space.

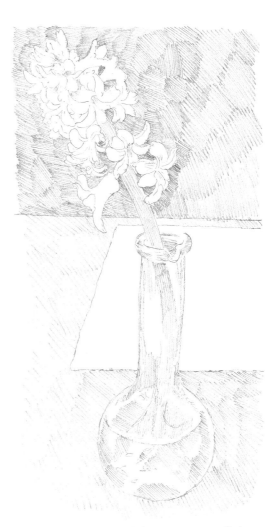

First make a light tone over all the areas where the shading will be, leaving untouched white paper for the highlights.

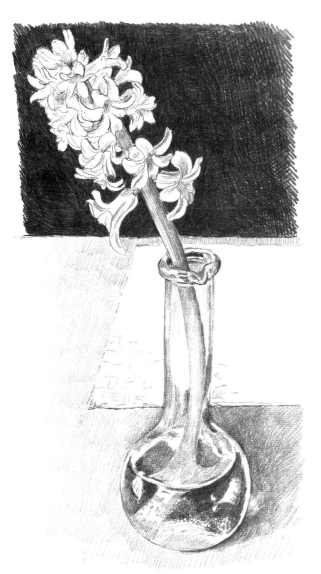

Following this, build up more varied depths of tone to give the objects substance. Note how I have placed the flowers against a dark background to show up their brightness, and the glass vase has a much lighter background in order to make the drawing of the glass simpler. Draw all the distortions that the water and glass produce to give a convincing impression of their quality.

Master examples

You can learn a huge amount by studying the work of professional artists from all eras, so we'll be looking at examples throughout this book. Here are two compositions that, although simple, are carefully thought out and executed.

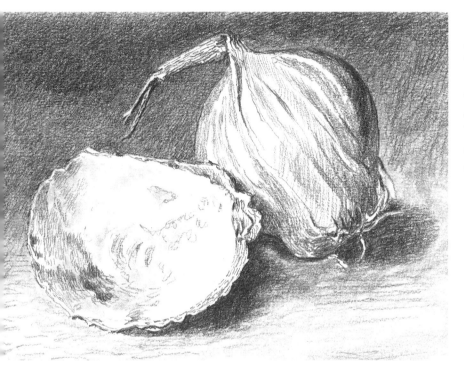

Here William Henry Hunt (1790–1864) has just placed an oyster shell and a large onion close together on a surface with a darker background. He makes the most of the different textures of the two things, so that as a study in materiality it's quite powerful. This is always a good way to approach a simple still life as it intensifies the viewer's experience.

Here's a still life that's simple enough in composition, although it's not easy to achieve this degree of sensitivity. The main thing to notice is just how carefully Henri Fantin-Latour (1836–1904) puts in the various tones of the leaves, all of which are darker than the flowers. The contrast between the flowers and the leaves, the jar and the tabletop, helps to give a feeling of the fragile quality of the blooms rather well. On pages 42–55 we shall be looking in more detail at drawing plants and flower still lifes.

Week 2

Composite still life

In this section of the book, we look at still life in more detail and with more complex composition. One of the ways that you can arrive at an interesting still-life arrangement is to look for accidental ones around your house. I find that every day I come across natural compositions of objects that have come into being by virtue of the everyday habits of living. Sometimes they are complete in themselves, while on other occasions they just need a slight alteration to make a very pleasing still life.

You'll find it useful to make separate drawings of all the objects that you choose for a large still life to familiarize yourself with their shapes and textures. This sort of preparation is never wasted, and you'll often achieve some very good examples of your drawing skills to refer to later on for another project.

The final arrangement of a still life should be made up of things that you find interesting in themselves. Don't put anything in the arrangement that you don't really want to draw. Have faith in your own taste – it really does make a difference to the intensity and quality of your work.

Last but not least, familiarize yourself with still lifes by artists whom you admire to gain some wider understanding of all the possibilities. This is a wide-ranging genre, and you will find many themes that appeal to you.

Choosing and assembling objects

When you move on to more ambitious still lifes composed of a larger number of objects you have to take more time to think about their arrangement. The first thing is to look around for objects that have some attraction for you, bearing in mind that they should give you some contrasts of shape and form. You may perhaps like the idea of drawing a set of things that are similar in shape, but this is best left until you have developed your skills further as it's more difficult to make a dynamic composition from them.

Look around your house to find about seven or eight objects that seem interesting. I often find that I've picked out too many things that have a similar shape, so I'll sometimes deliberately look for things that I'm less automatically attracted to.

Here are two objects that I chose for the very reason that they are dissimilar. The pot with paintbrushes stuffed in it is a complex thing to draw and has a vertical thrust, while the wooden box is very simple and has a strong horizontal shape. These would give plenty of contrast in a composition and might provide an interesting dynamic for the final arrangement.

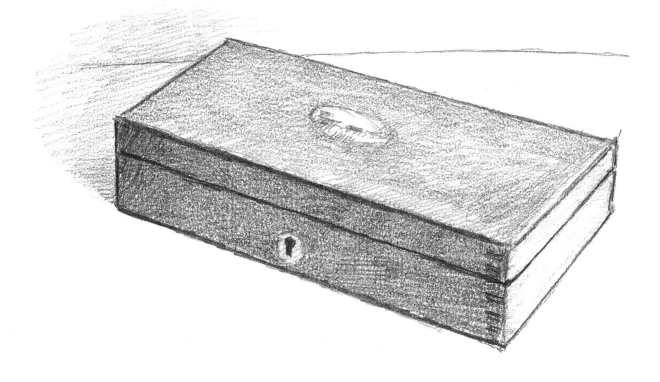

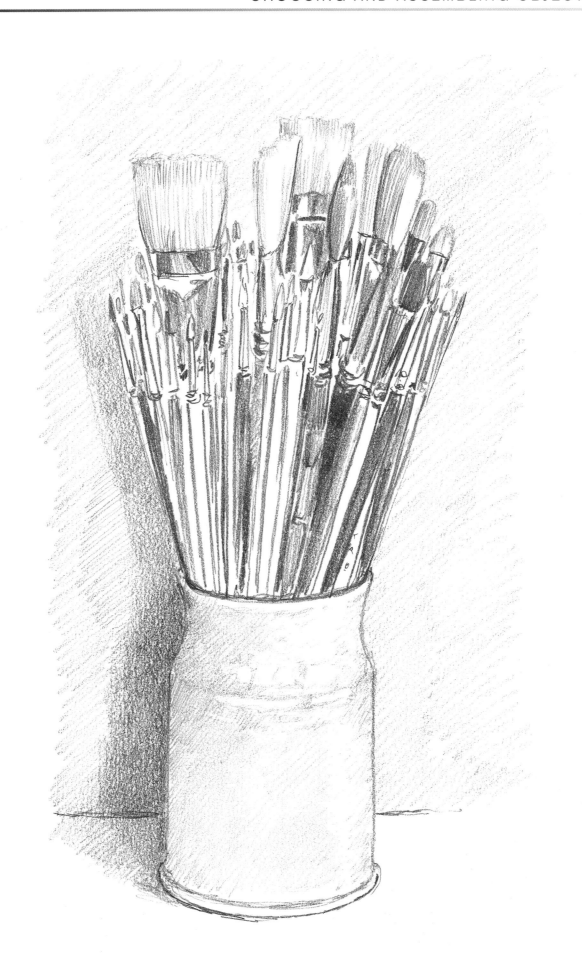

Then I looked around and noticed an ironing board with a shirt, an up-ended steam iron and a jug of water that my wife had been using to fill the iron. While this in itself makes a good set of shapes, it's rather limited in the number of objects and wouldn't look very natural if others were added.

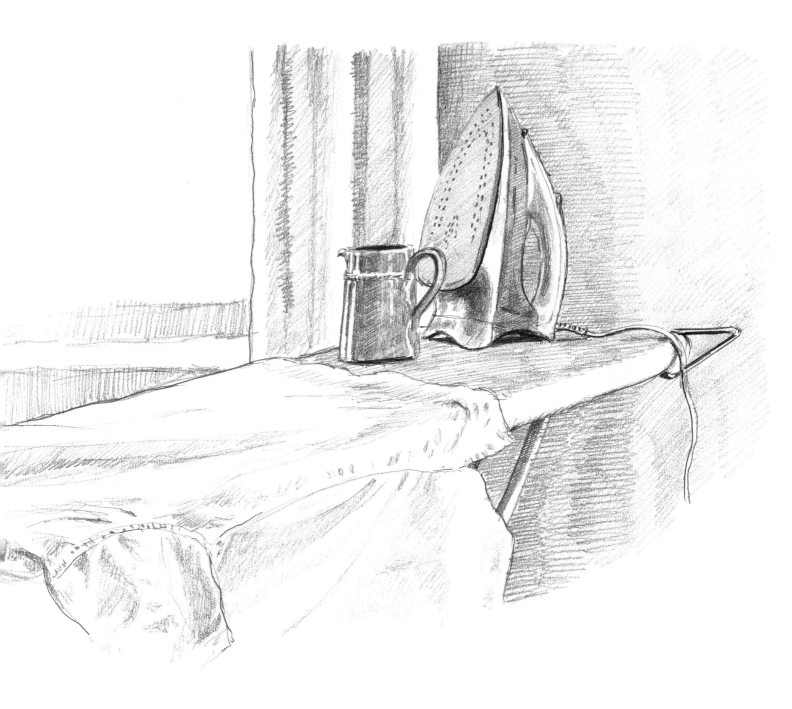

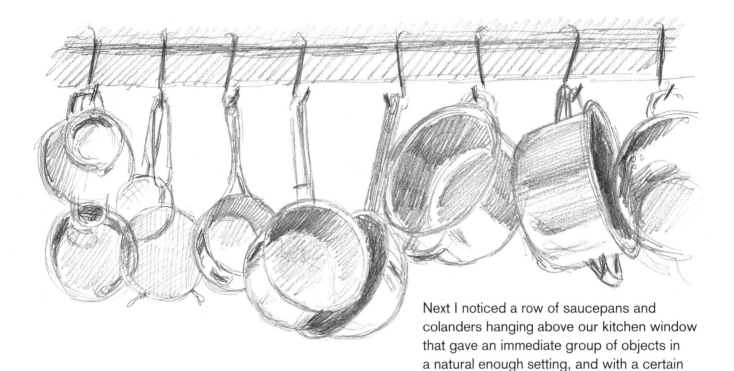

Next I noticed a row of saucepans and colanders hanging above our kitchen window that gave an immediate group of objects in a natural enough setting, and with a certain drama because of the lighting from behind. However, it was a rather elongated shape as a whole, and there wasn't much contrast between the shapes.

Still in the kitchen, I assembled several objects on the worktop to see if they would make a good arrangement. The lighting was again fairly dramatic and the objects were quite interesting in themselves. But somehow I was still not satisfied with the composition, so I looked around again.

This gives you some idea of the kind of task you are setting yourself when you decide to draw a more complex still life – but it's worth the trouble to put some thought and imagination into it rather than just choosing the first things that you come across.

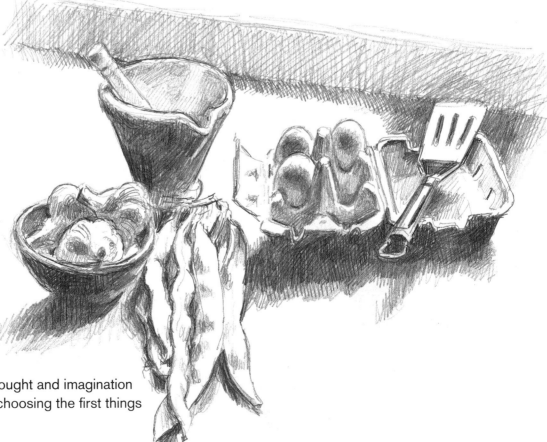

Still life details

It will pay dividends if you practise drawing all the individual components of a still life rather than having a go at them for the first time as part of a composition. You'll feel more confident that you can complete the still life and there'll be less erasing to do as you go along.

First draw a piece of cloth such as a tea towel, folded simply. This will give you some idea about the final work.

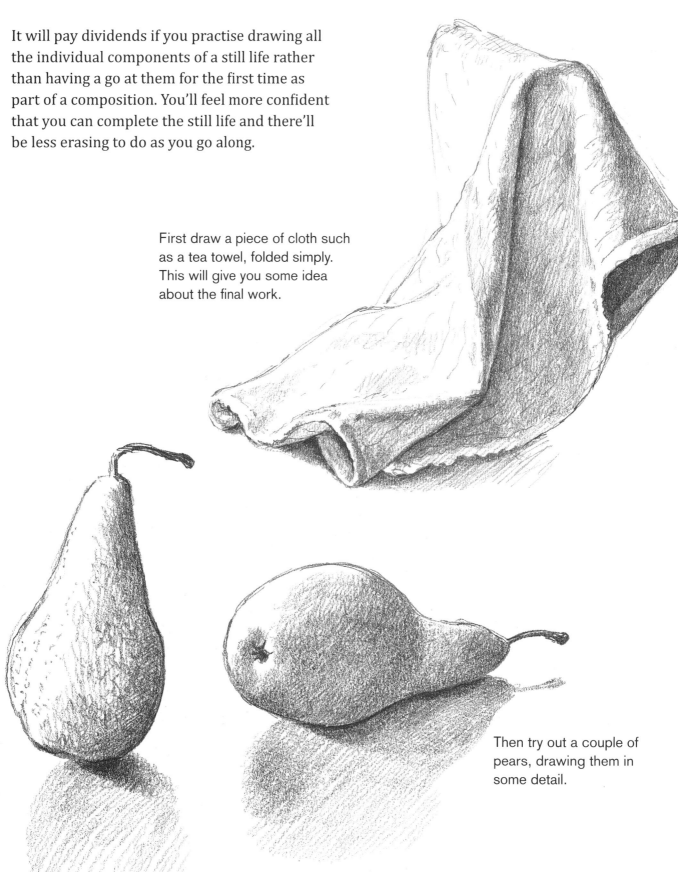

Then try out a couple of pears, drawing them in some detail.

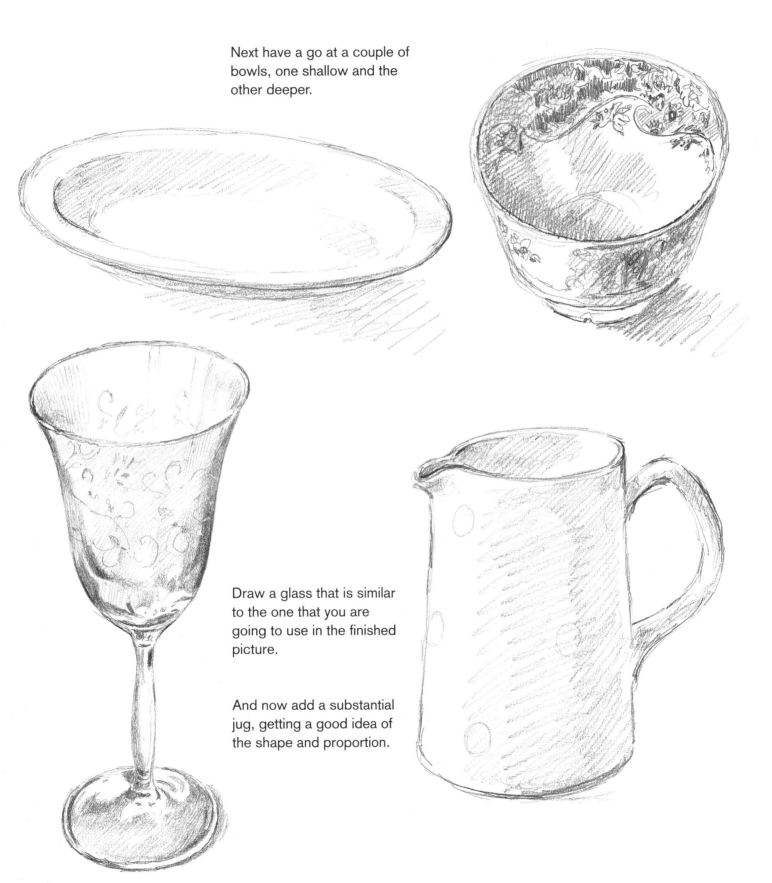

Next have a go at a couple of bowls, one shallow and the other deeper.

Draw a glass that is similar to the one that you are going to use in the finished picture.

And now add a substantial jug, getting a good idea of the shape and proportion.

A still life arrangement

You are now ready to embark on this classic still-life arrangement with a piece of cloth draped as a background, some fruit on a dish, a wine glass, a jug and a cup and saucer. This is of course fairly contrived, but as a test of your drawing ability it gives you some very interesting problems.

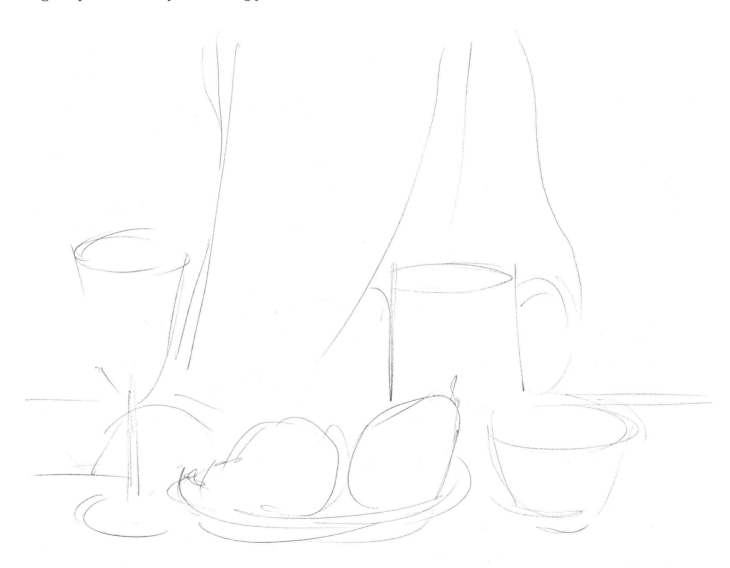

I placed the dish with two pears on it in the centre of the foreground with the jug tucked in just behind it, on one side. Then I draped a tea towel on a board behind them to make a nice set of folds that weren't too complex. It's a good idea to keep the background fairly simple for a still life of this type.

Then I put an etched wine glass to the left and a small willow-pattern bowl in the right foreground. So here I had seven objects in an arrangement

with a good variety of shapes and textures.

After looking very carefully at the whole composition, your first step is to loosely draw in the main bulk of the various objects to get some idea of the proportion and balance of the various parts. Try to get the sizes of the objects and their relation to each other as accurate as you can, since taking trouble at this stage can save you a lot of work later on.

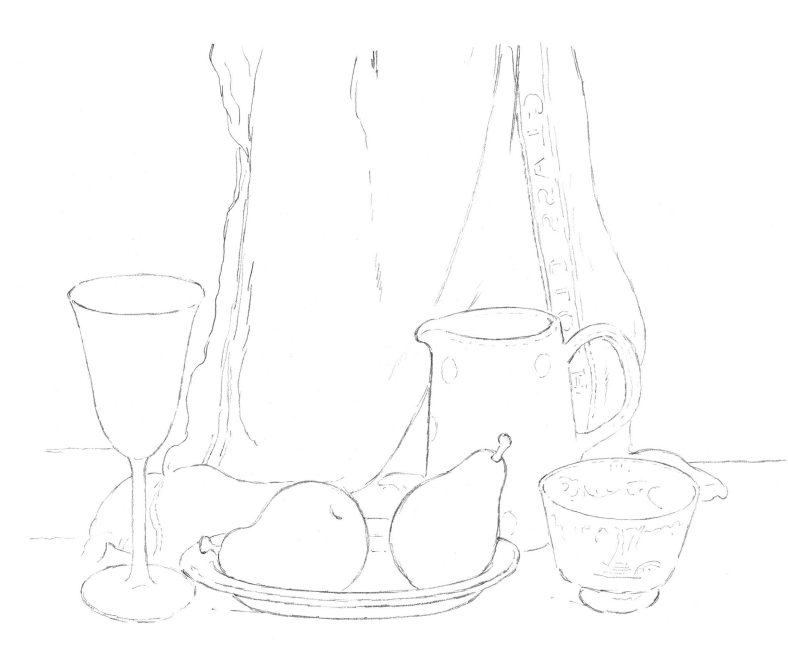

Now you need to draw in the full shape of each object more carefully, making sure that the shapes are as accurate as you can achieve. After the whole thing is finished you'll probably realize that there are some things that you might have drawn better, but don't worry – that always happens and it will make you want to go on to the next drawing in order to grow more skilful. Get it as good as you can at this stage, then don't look back.

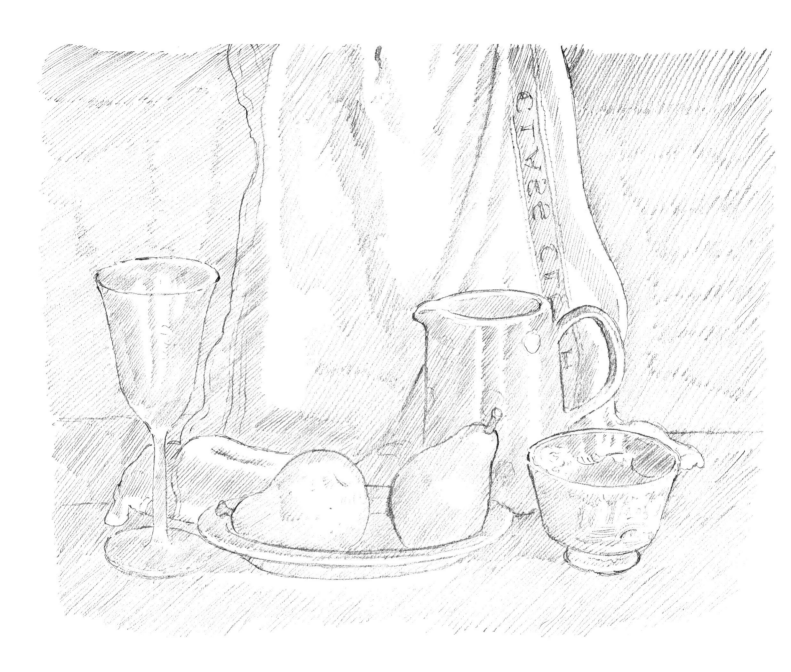

The next step is to add tone over all the shadowed parts that you can see on the still life. I had light coming from the right-hand side and slightly from the front, so there was quite a lot of tone present. Keep the pencil marks light and uniform all over the picture at this stage. I have drawn my tone all in one direction to make it more obvious as a demonstration, but it doesn't matter if you vary the pencil strokes as long as you keep the depth of tone light.

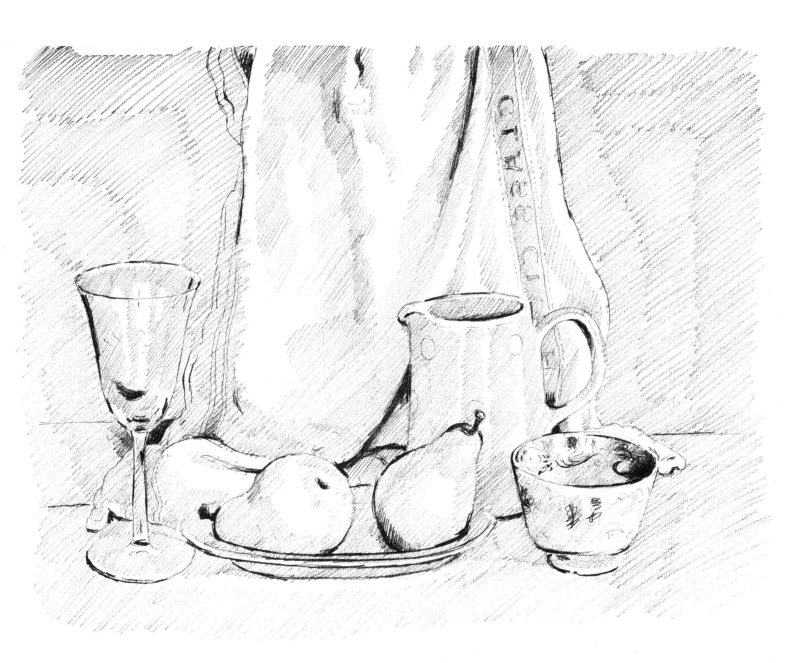

Put in all the very darkest areas so that you now
have the very darkest and very lightest tone on the
paper. This gives you the two extremes between
which the mid-tones will be.

Finally, put in all the graduated tones that will harmonize the whole picture and make it look more convincingly three-dimensional. Build these up gradually and keep stepping back from the picture so that you can see how they are working. The more subtle your tonal values are, the more convincing the picture will look. This is a very useful practice – and always remember that you become good at what you practise.

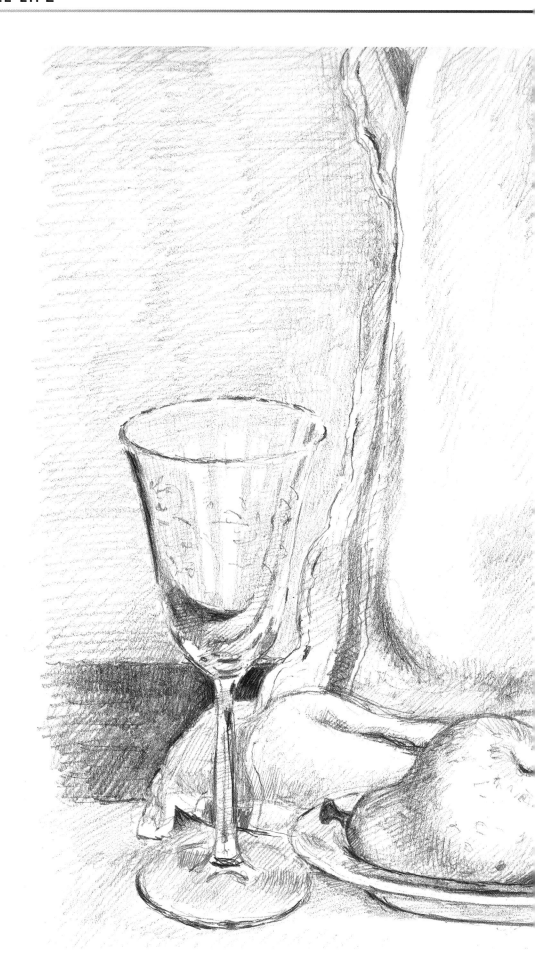

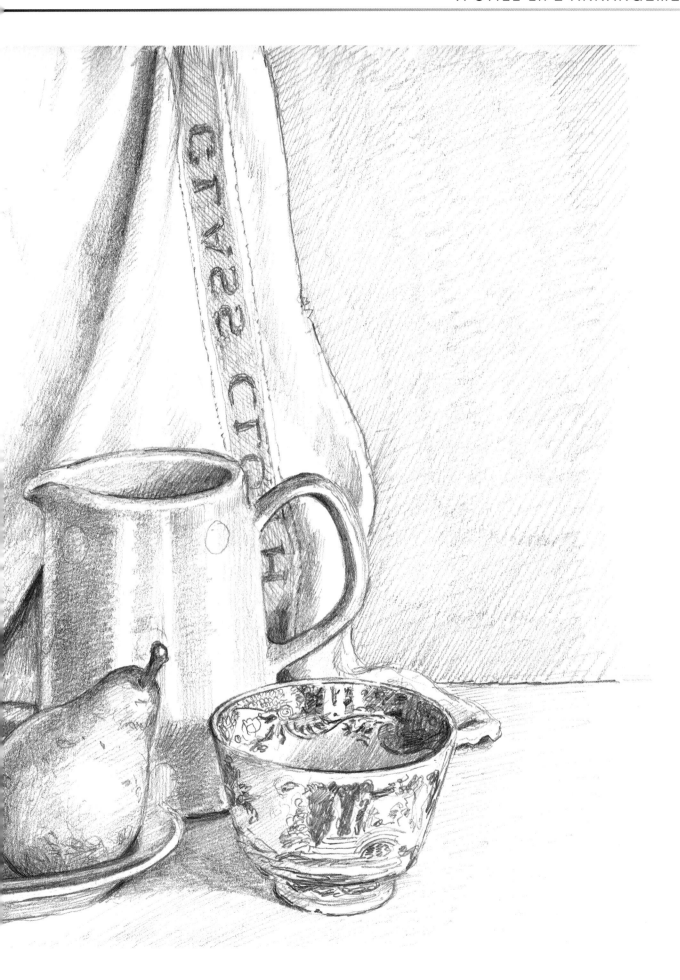

Master examples

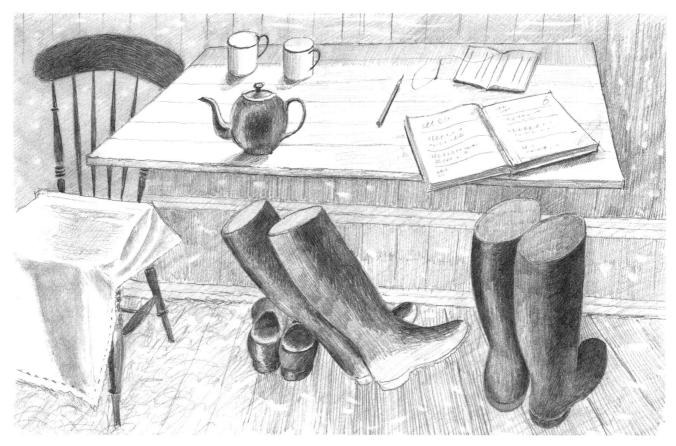

A less traditional form of still life is this one after Eric Ravilious (1903–42) of two pairs of wellington boots, a chair and a table with cups, teapot and notebooks arranged on it.

This picture after the artist Pieter Claesz (1597–1660) shows how a very satisfying arrangement can be produced with only a few objects that possess some contrast in shape and texture.

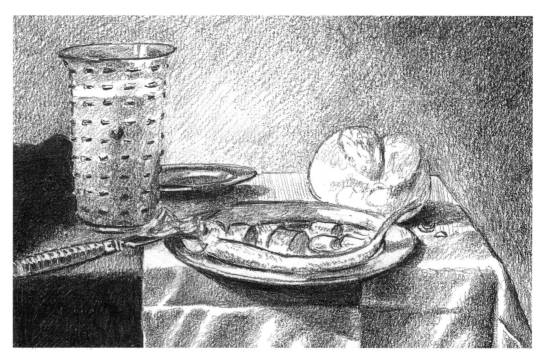

Week 3

Still life with plants

In this chapter you'll learn how to draw plants, which will require sharpening your powers of observation as their natural forms are more subtle and delicate than the man-made objects you have tried. To start with, draw simple shapes; any leaf form is of value because although leaves are relatively straightforward, they have all the subtleties that more complex plants will demand from your skills.

Of course, the plants you wish to draw will often be held in a container, so you'll be including some of the forms that you have already drawn in this new area of natural growth. One difference you'll notice is that although plants are supposedly inanimate for

the purposes of a still life, there's always some movement in their growth that means that no drawing you do can ever be completely final. Don't expect to feel you have produced the ultimate portrait of a plant since, like humans and animals, they are always changing.

Drawing plants is certainly a challenge, but with practice you'll soon get the hang of it. Just remember to approach the task with an understanding of not just their fragility but also the great deal of vigour they possess as well. At the end of this section I have shown work by master artists that should help you to gain some ideas about different aspects of drawing botanical subjects.

Developing natural forms

In my garden one day, I happened to notice the beauty of several of the leaves scattered on the lawn. I picked up a few and took them inside to make these drawings, carefully studying their shapes and textures. Have a go at doing the same, all the while trying to draw exactly what you see.

Notice how you can concentrate on a small object such as this with great precision, showing how the veins of the leaf shape the outer form and how, as the leaf starts to dry out and decay, the edges curl up and form interesting shapes. When you try this out, give every detail your attention and treat the leaf as seriously as you would a large, complex object. Draw the shadow as well and see how your dedication makes the small leaf become a really powerful image.

Try several leaves, using examples that you can find easily and that attract you by their colour or shape. This concentration of energy into drawing a simple object is the key to improving your drawing skills.

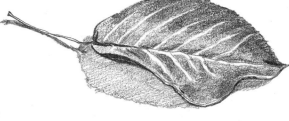

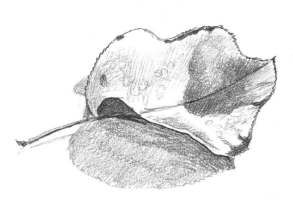

Now go a step further. Select some flowers that you find attractive – you will give them more attention if you like the look of them – and then proceed to draw one or two blooms with the same sort of detailed attention that you gave to drawing the leaves. You will need to be a little more delicate in the way you approach them because they are much more fragile and exquisite than the leaves, which have a rough vigour.

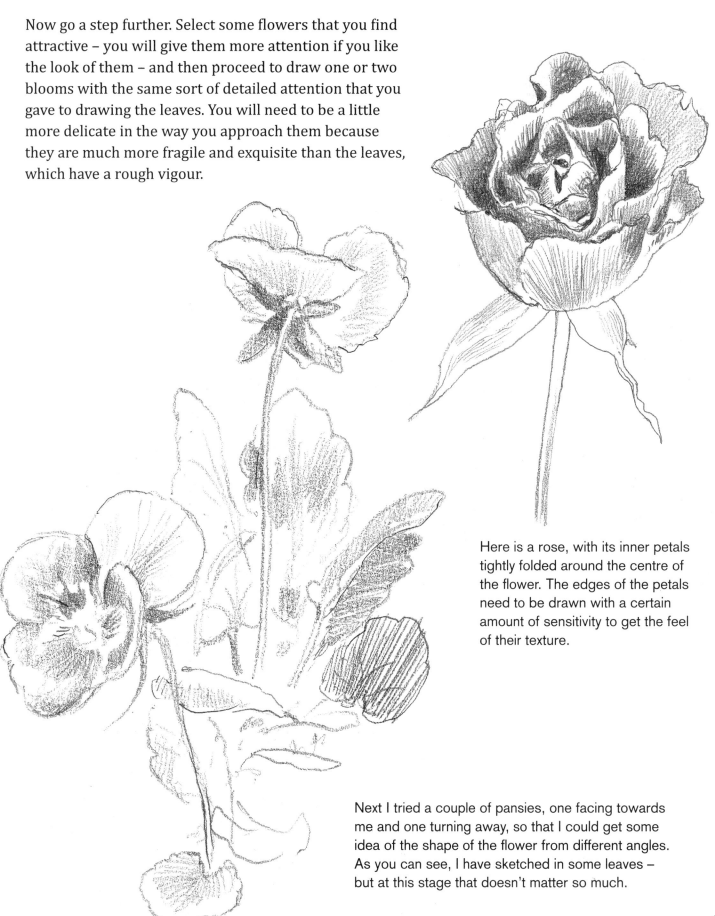

Here is a rose, with its inner petals tightly folded around the centre of the flower. The edges of the petals need to be drawn with a certain amount of sensitivity to get the feel of their texture.

Next I tried a couple of pansies, one facing towards me and one turning away, so that I could get some idea of the shape of the flower from different angles. As you can see, I have sketched in some leaves – but at this stage that doesn't matter so much.

A still life of plants

A plant still life can be either formal or informal – for example, a vase of flowers usually gives a more formal effect than plants in a flowerbed or window box. The one shown here is a large box of various herbs.

Start as usual with a very loose sketch of the main shapes of the plants, getting some idea of the way that they grow.

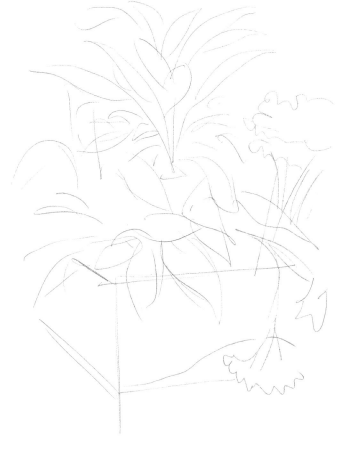

Next comes a line drawing to put in all the leaves and stalks so that the plants are differentiated. At this stage you should make any necessary corrections – although the shapes may be changing all the time if you are working outside in the slightest breeze.

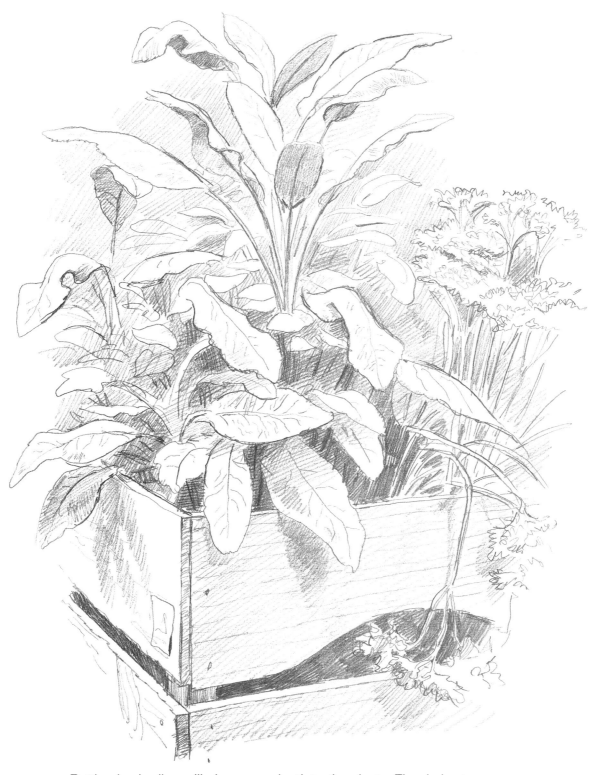

Putting in shading will give some depth to the plants. The darkest
shadows go in first, then gradually build up the different tonal areas
until the result looks fairly realistic. There is no need to draw the
smaller leaves exactly – just put them in with an expressive scribble.
The contrast between the box and the leaves helps to make the leaves
look softer and more fragile.

Pots and vases

Then I turned my attention to the sort of pot or vase that I might use to put the flowers in. This is all part of drawing a still life with plants, because you will mostly want to draw them in the comfort of your studio or house. I have tried a couple of glass pots, one suitable for a single flower, and a couple of ceramic vases, one small and the other large.

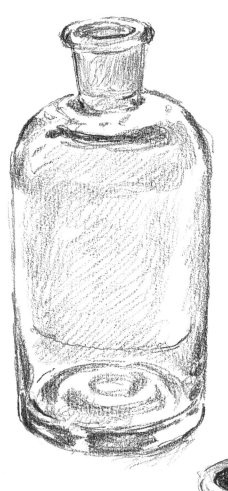

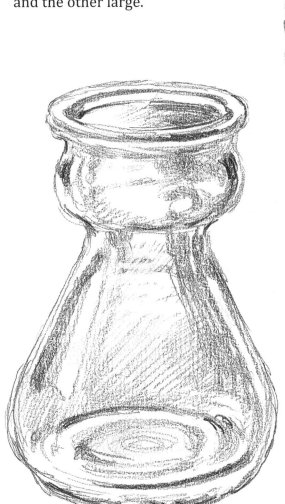

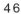

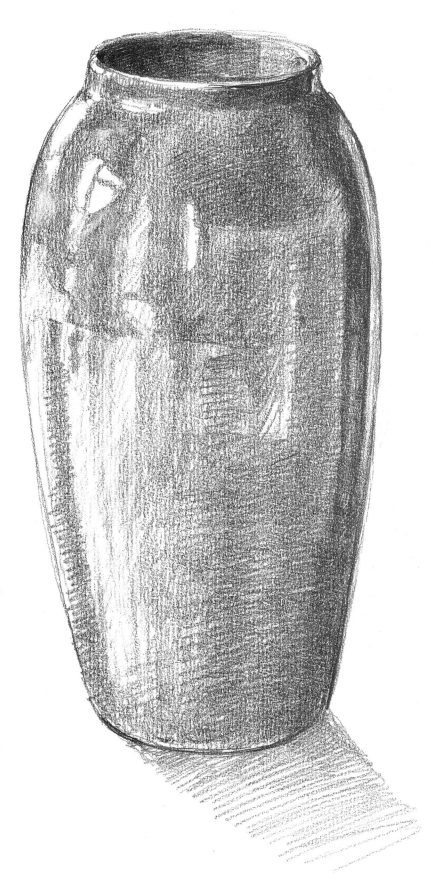

For this large vase I first put in tone across the whole shape and the cast shadow, leaving white spaces for the very brightest reflections at the top rim and down the length of the left side of the pot. Then I built up the tone to the very darkest on the right-hand side, allowing for patterns in shading to suggest reflections on the shiny surface.

A vase and flowers

The next step is to take your courage in both hands and attempt a whole bunch of flowers in a vase, just concentrating on the flowers rather than the vase as well. I came across an arrangement that my wife had put in one of our rooms and decided to make a careful drawing of the whole bunch. When you draw this yourself, block in the large group of flowers in a simple fashion to start with. This will make the final drawing much more effective, and will probably save time as well.

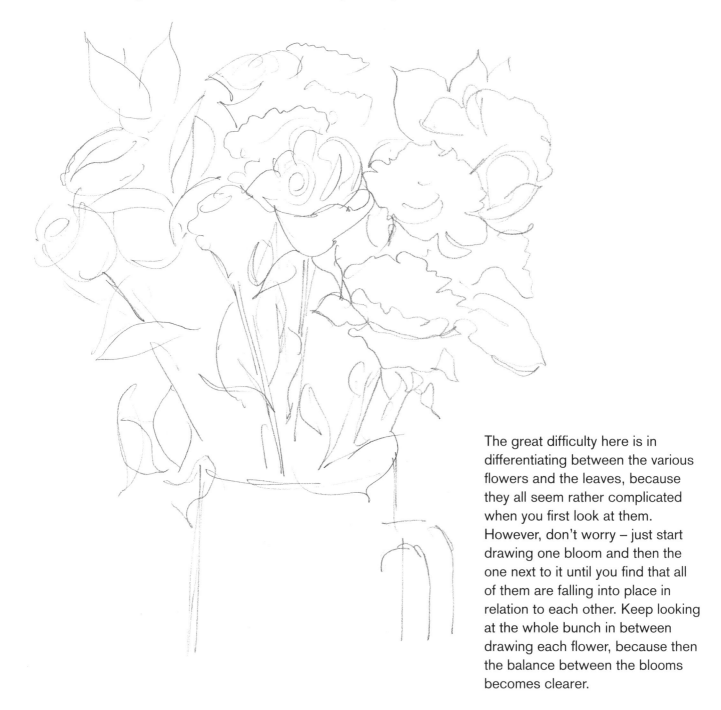

The great difficulty here is in differentiating between the various flowers and the leaves, because they all seem rather complicated when you first look at them. However, don't worry – just start drawing one bloom and then the one next to it until you find that all of them are falling into place in relation to each other. Keep looking at the whole bunch in between drawing each flower, because then the balance between the blooms becomes clearer.

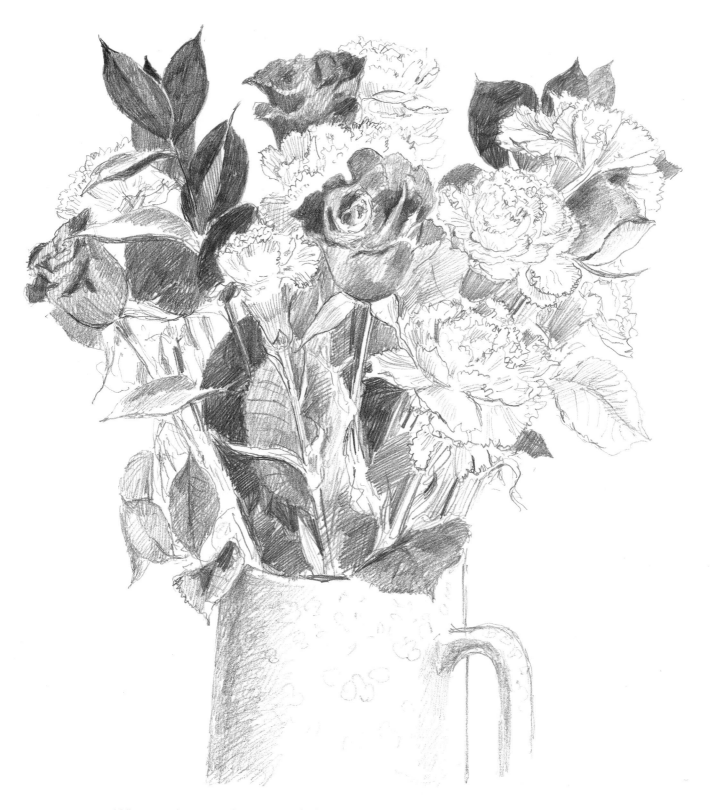

When you've completed the whole arrangement, notice how much you may have changed its appearance, either in proportion or general shape. This doesn't matter much in itself because no one will know except you, but it's useful to see how distortions may find their way into your drawing so that on your next attempt you'll be on the lookout to correct them as you go.

Arranging a plant still life

When trying out various arrangements for my plant still life I made sure that I drew as many different compositions as I could to give myself some experience in dealing with the objects that would feature in the final picture.

I found this first arrangement far from interesting because the objects were spaced too widely across the table and they didn't form a coherent group.

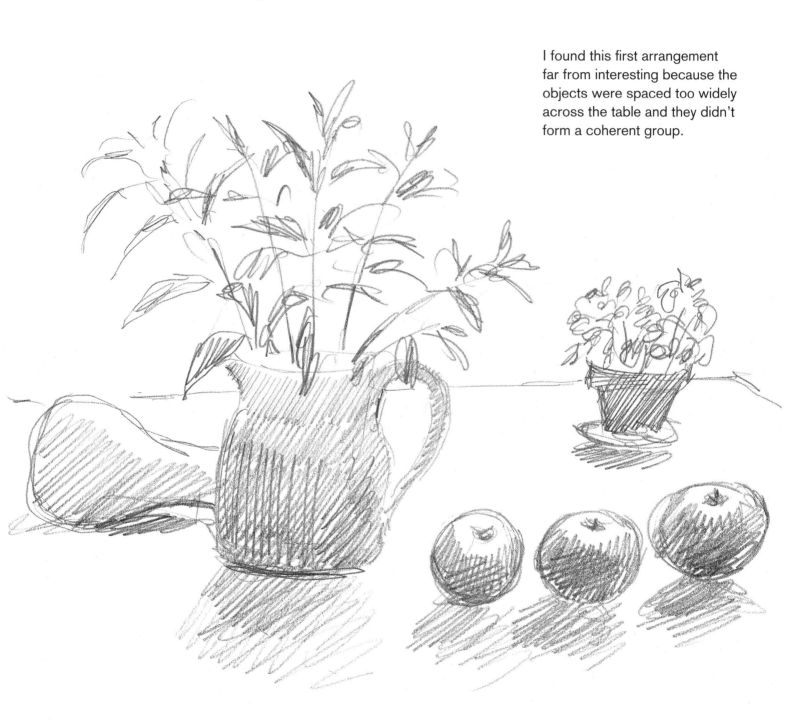

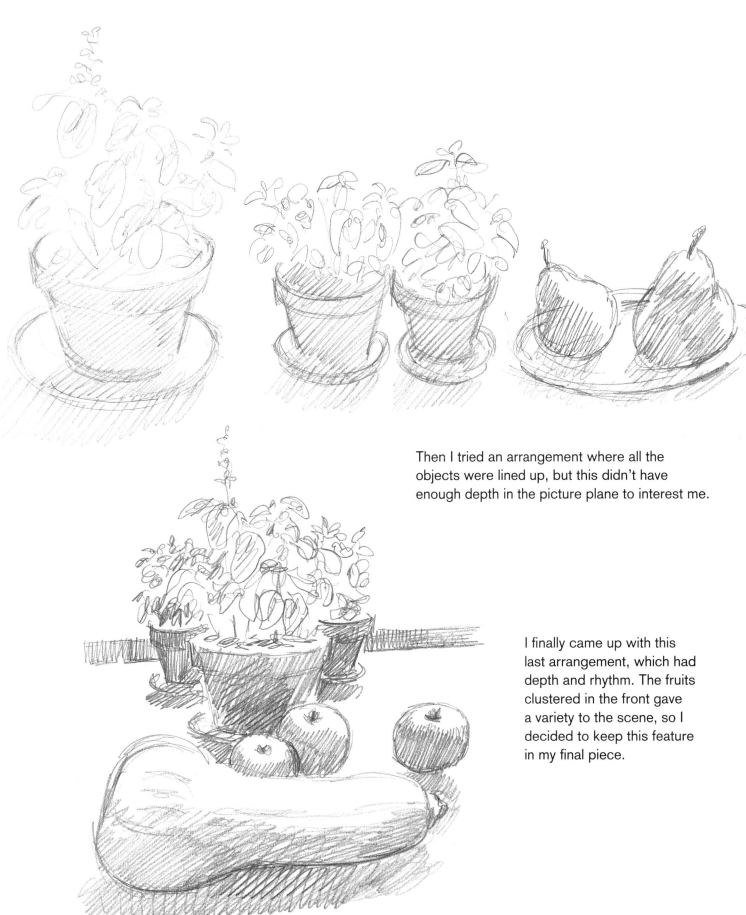

Then I tried an arrangement where all the objects were lined up, but this didn't have enough depth in the picture plane to interest me.

I finally came up with this last arrangement, which had depth and rhythm. The fruits clustered in the front gave a variety to the scene, so I decided to keep this feature in my final piece.

A plant still life project

Now comes the final task – to arrange a still life composed mainly of plants, but with a few other items to give some balance to the composition.

I noticed some potted plants set on saucers on our windowsill that seemed to make a nice set of shapes, so I decided to use these as the main background of the picture. Next I took an arrangement of autumn leaves in a jug and placed that as the main focal point of the composition.

To give a bit of variety to the foreground, I put a large squash and a couple of apples alongside the jug. Now I had a composition that mostly consisted of plant life, although in this case I didn't have any flowers on show. One of the leaves dropped off the main arrangement and lay on the table in front of the jug – a nice accidental touch. The lighting was largely from the left side, with some from behind the arrangement too.

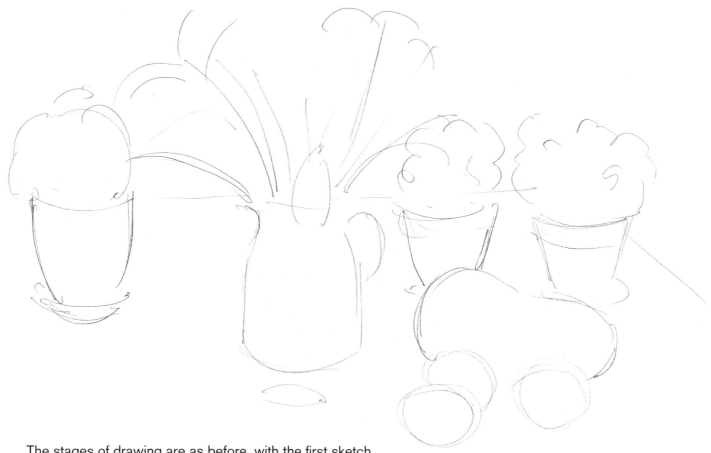

The stages of drawing are as before, with the first sketch defining the outside shape of the whole group, without any real detail. This enables you to get the main shape of the whole picture right before you start drawing the actual shapes of the plants.

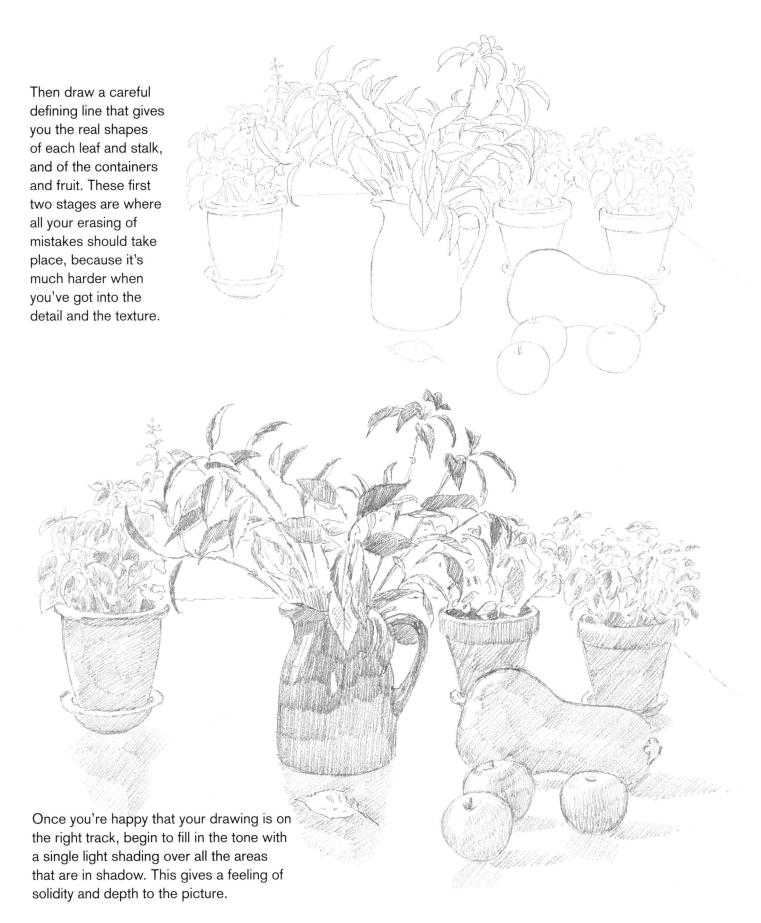

Then draw a careful defining line that gives you the real shapes of each leaf and stalk, and of the containers and fruit. These first two stages are where all your erasing of mistakes should take place, because it's much harder when you've got into the detail and the texture.

Once you're happy that your drawing is on the right track, begin to fill in the tone with a single light shading over all the areas that are in shadow. This gives a feeling of solidity and depth to the picture.

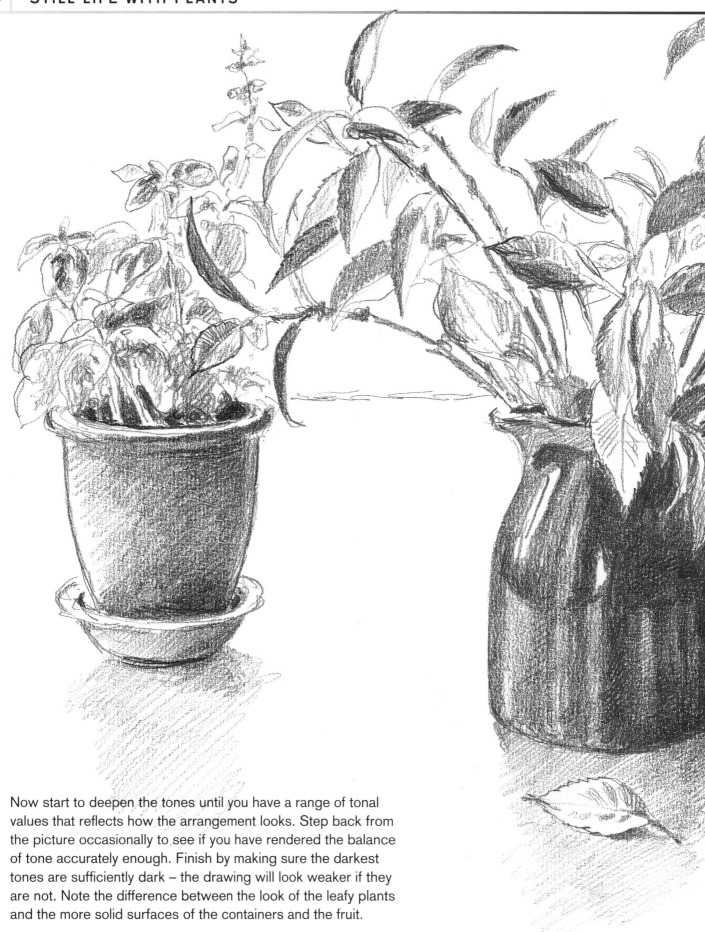

Now start to deepen the tones until you have a range of tonal values that reflects how the arrangement looks. Step back from the picture occasionally to see if you have rendered the balance of tone accurately enough. Finish by making sure the darkest tones are sufficiently dark – the drawing will look weaker if they are not. Note the difference between the look of the leafy plants and the more solid surfaces of the containers and the fruit.

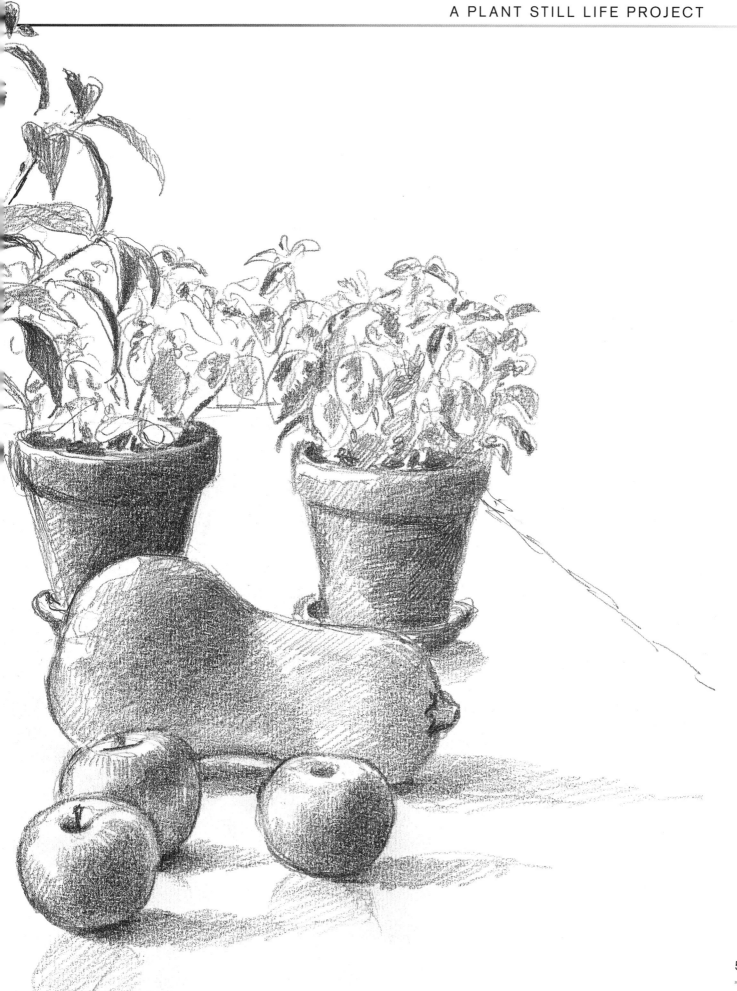

Master examples

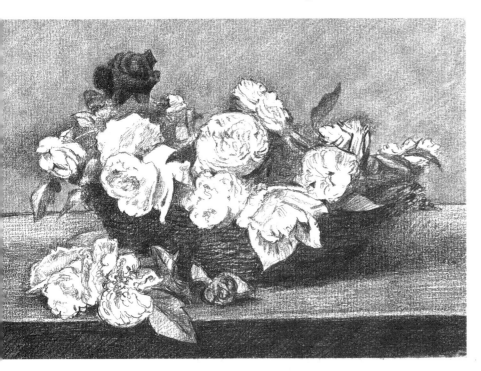

Henri Fantin-Latour was renowned for his beautiful and intense flower paintings (see also p. 26). Here he shows us a basket of roses with some fallen on to the table in front. This forms the whole of the composition and in lesser hands could be a dull picture, but Fantin-Latour's skill is such that you can almost feel the texture of the petals.

G.D. Ehret (1710–70) was a well-known botanical artist. His drawing is very precise, because his aim is to show the exact shape of the plant so that it can be identified easily. You may not want to do this more technical drawing for finished pictures, but it's worth trying it sometimes in order to improve the accuracy of your drawing.

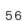

Week 4 Landscape

This section of the book starts with a practice session, because landscape is an enormous and variable subject and any preparation for it will never be wasted time. What you'll soon notice is that landscape is all about textures, from the reflective surface of still water to rough grasses and rugged stony ground. You'll also begin to realize that what you draw on a small scale can be replicated on a larger one, which will give you confidence: if you can draw a foreground rock convincingly, you can draw a mountain too.

Looking through a frame made by cutting an aperture in a piece of card will help you to select a manageable composition from an expanse of landscape, which can be confusing at first. You may be lucky enough to have an enchanting rural scene close by, but if not there will probably be a local park or nature reserve that will stand in for a bigger view.

However, if this is the case it won't be long before you want to make a journey to more open countryside, and you will need to make sure you are well-equipped. Arm yourself with plenty of well-sharpened pencils so that you do not have to keep sharpening your only one. A hard-backed sketchbook is also a good investment for this sort of work – and get yourself into the mood by drawing plenty of vegetation first to limber up for the moment of truth!

The textures of landscape

Before making a start on a larger scene, it is useful to familiarize yourself with some of the elements of landscape, including grass, plants, stones and water. None of these exercises is purely observational, but they use techniques based on observation to build up the textures you'll need for landscape drawing.

1 In this first exercise the method is to scribble lines outwards, without taking your pencil off the paper, until you have built up a mass of texture that rounds out into a bush shape. Then strengthen the marks significantly around one side to give a sense of depth.

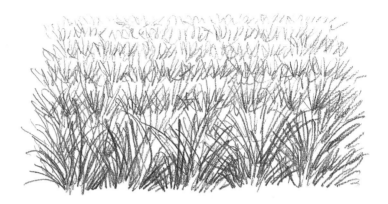

2 The second practice produces the effect of an area of grass, again using simple scribbled marks. Working from the bottom upwards, gradually reduce the strength and the depth of your marks. This gives the impression of tufts of grass receding into the distance.

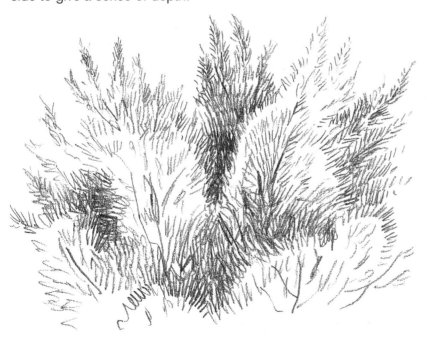

3 This drawing of a pine tree uses simple pencil strokes to represent the texture of the foliage. Note how I have put in some marks that resemble branches to help show the structure of the tree. In some parts I have made the marks darker to denote deeper shadow.

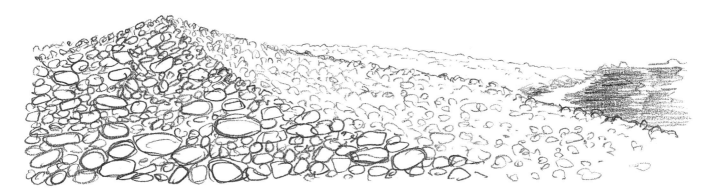

4 Now we move on to a pebble beach, where you have to be patient enough to draw lots of pebble shapes of varying sizes. The closest pebbles are drawn strongly and in some detail. On the far side of the ridge of stones, draw marks that look less definite and appear to be only the tops of pebbles, to give the impression of distance.

5 Moving on to the sea itself, this scene shows the ripples of waves as they recede to the horizon, where they become just a strip of tone. Draw the wave shapes in undulating horizontal lines.

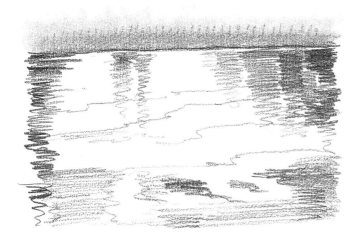

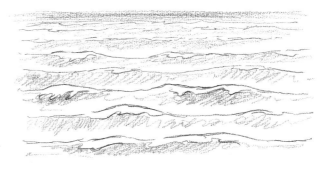

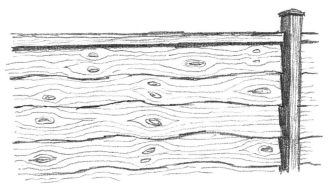

6 This pond water is less agitated than the sea. To achieve the glassy quality of the still water, lay your marks down smoothly in horizontal strokes, leaving areas of light, and put in darker tones around the edges.

Test

7 The final exercise is to look at the texture of a fence. Mark in the main structure and supporting post first, then draw in the planks with wavy lines, and some knot-hole shapes at various points on the planks.

Understanding perspective

The science of perspective is something with which you will have to become acquainted in order to produce convincing depth of field – a sense of distance – in your landscapes. This is especially important if you want to draw urban landscapes. The following diagrams are designed to help you understand how perspective works and so enable you to incorporate its basic principles in your drawings.

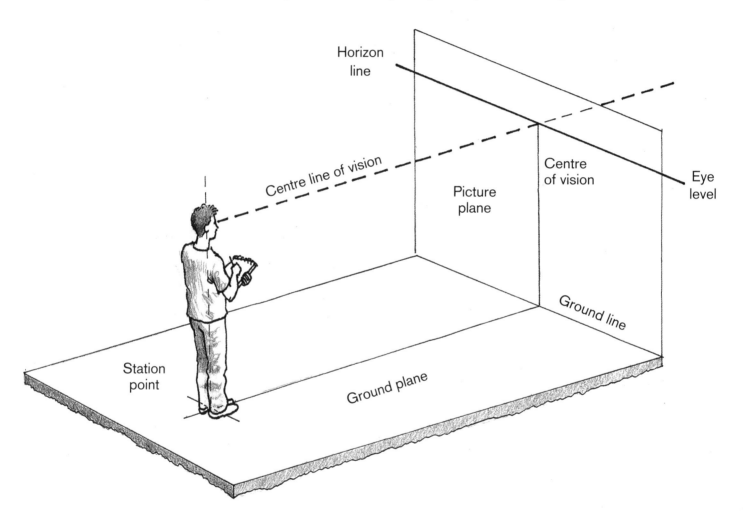

Like any science, perspective comes with its own language and terms. This diagram offers a visual explanation of the basic terms as well as giving you an idea of the depth of space. The centre line of vision is the direction you are looking in. The horizon line or your eye level produces the effect of the distant horizon of the land or sea. The picture plane is effectively the area of your vision where the landscape is seen. The other terms are self-explanatory.

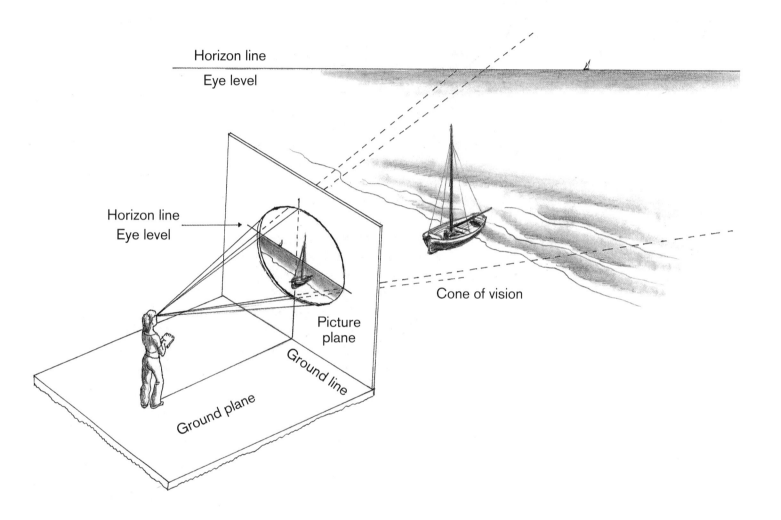

Horizon line
Eye level

Horizon line
Eye level

Cone of vision

Picture
plane

Ground line

Ground plane

The cone of vision is a sort of mental construct of how much you can draw without the effects of distortion appearing in your picture. In practice it is what you can take in of a scene without turning your head; it extends to about 60 degrees across. The cone of vision in our illustration encompasses the whole view right to the distant horizon. When you look through the lens of a camera, you may have noticed that the shapes of the objects on the periphery of your vision appear to be slightly different from how they are when you look directly at them. Here, the impression of the scene through the cone of vision is that the nearer areas are much larger than the distant areas, whereas in reality the reverse is true. The cone of vision is of necessity a narrow view of a scene.

Types of perspective

The eye being a sphere, it comprehends the lines of the horizon and all verticals as curves. You have to allow for this when you draw by not making your perspective too wide, otherwise a certain amount of distortion occurs. Below we look at three types of perspective, starting with the simplest.

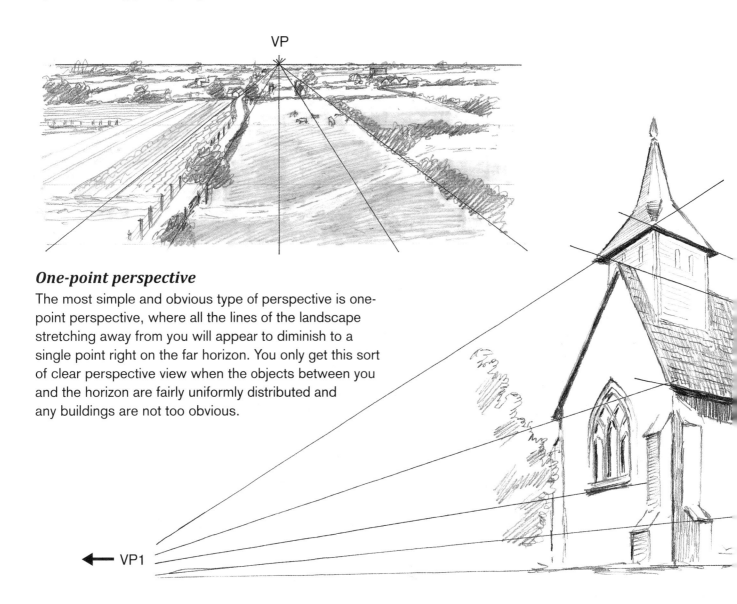

One-point perspective

The most simple and obvious type of perspective is one-point perspective, where all the lines of the landscape stretching away from you will appear to diminish to a single point right on the far horizon. You only get this sort of clear perspective view when the objects between you and the horizon are fairly uniformly distributed and any buildings are not too obvious.

Two-point perspective

Where there is sufficient height and solidity in near objects (such as houses) to need two vanishing points at the far ends of the horizon line, two-point perspective comes into play. Using this, you can calculate the three-dimensional effect of structures to give your picture convincing solidity and depth.

The vanishing points will usually be too far out on your horizon line to enable you to plot the converging lines precisely with a ruler. However, if you practise drawing blocks of buildings using two vanishing points you will soon be able to estimate the converging lines correctly.

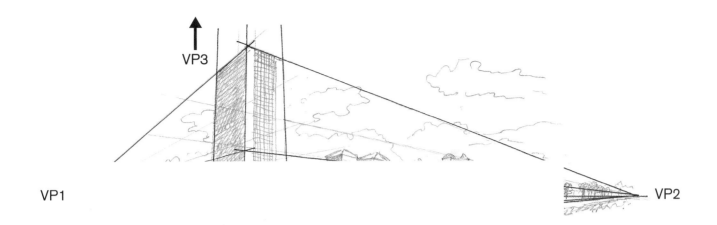

Three-point perspective

When you come to draw buildings that have both extensive width and height, you have to employ three-point perspective. The two vanishing points on the horizon are joined by a third which is fixed above the higher buildings to help create the illusion of very tall architecture. Notice in our example how the lines from the base of the building gently converge to a point high in the sky. Once again, you have to gauge the rate of the convergence. Artists often exaggerate it in order to make the height of the building appear even more dramatic. When this is overdone, though, you can end up with a drawing that looks like something out of a comic book.

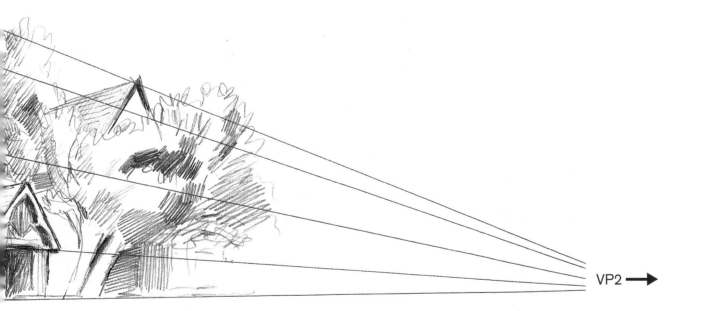

A scene in perspective

Using the techniques of showing perspective that you've just been learning, you are now going to draw an urban landscape. You should have largely got the hang of how to construct the drawing of architectural forms so that you can produce a convincing picture, but if you're not satisfied with the end result, don't be discouraged – everything will slot into place with repetition of the basics.

This is essentially a perspective exercise, but approached in an artistic rather than scientific way. Your eyes will give you all the information that you need to draw accurately, but your perspective studies will help the mind to make more sense of it and ease the process of drawing. For your own composition, choose a location that is straightforward and check on the weather first to ensure that rain or wind won't make things more difficult for you.

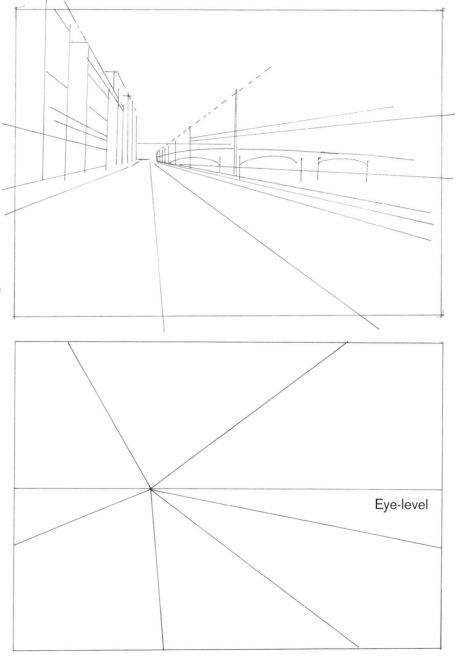

Here is an outline drawing of a street by the Arno river in Florence, Italy. I haven't included any human figures or cars to make it easier to see the perspective.

Now look at this diagram of the perspective lines that underlie the original drawing, consisting merely of the horizon line and the main lines that join at the vanishing point. These should inform your own drawing, even if you don't actually put them all in with a ruler. So your task is to find a street scene and, if it looks too complex, simplify by leaving out any street furniture and buildings that confuse you. Draw from life, at the scene, bearing in mind what you now know about perspective construction.

Eye-level

Put in the main shapes first and the details later, when you are sure that the main blocks of the scene are reasonably convincing.

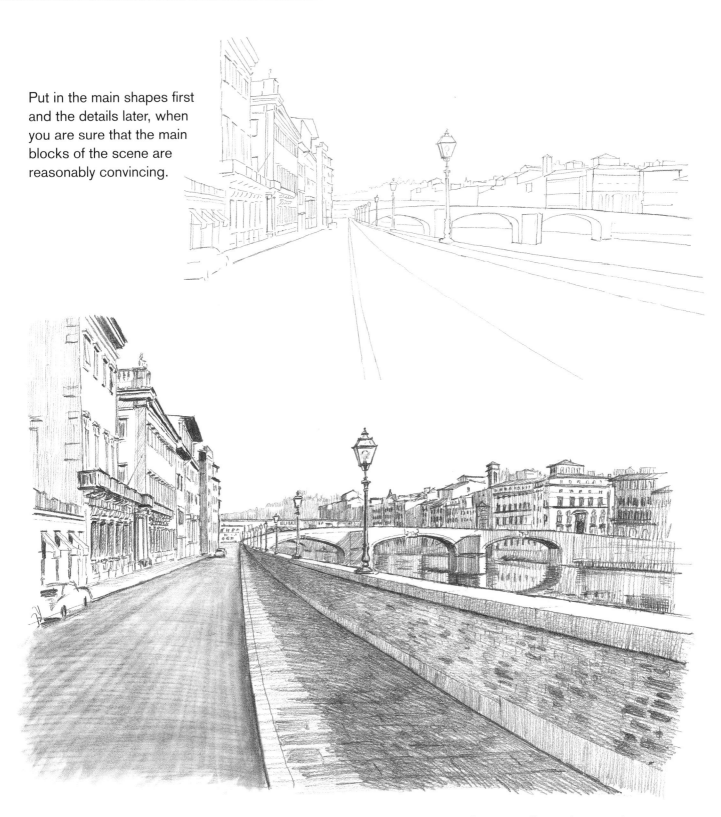

When you have added all the detail you need, put in the tonal areas, using textures to differentiate the various surfaces of the scene. I have given the road a smoother texture than the adjoining pavement and wall by smudging the pencil marks with a stump.

Notice also how the more distant features have less definition than those in the foreground, which helps to convince the eye of the picture's three-dimensional quality.

Landscape composition

Perspective is often less clear-cut in rural scenes than it is in townscapes, where the angular forms of buildings will quickly betray any errors in perspective drawing you might make. It is immensely valuable, though, as it allows you to give your landscape a three-dimensional quality and also to invite the viewer into the picture. Whether your landscape is pastoral, mountainous or a seascape, you can employ lines of perspective in order to direct the viewer's eye where you want it to go.

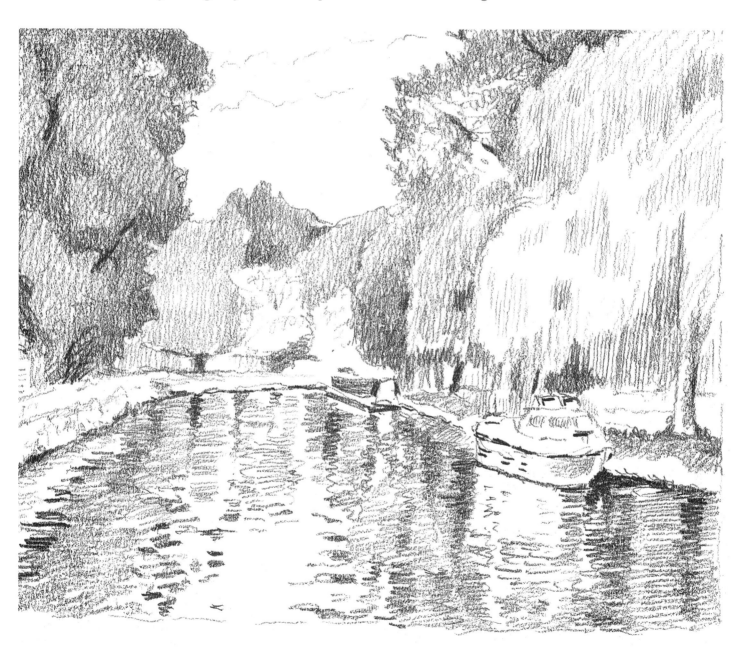

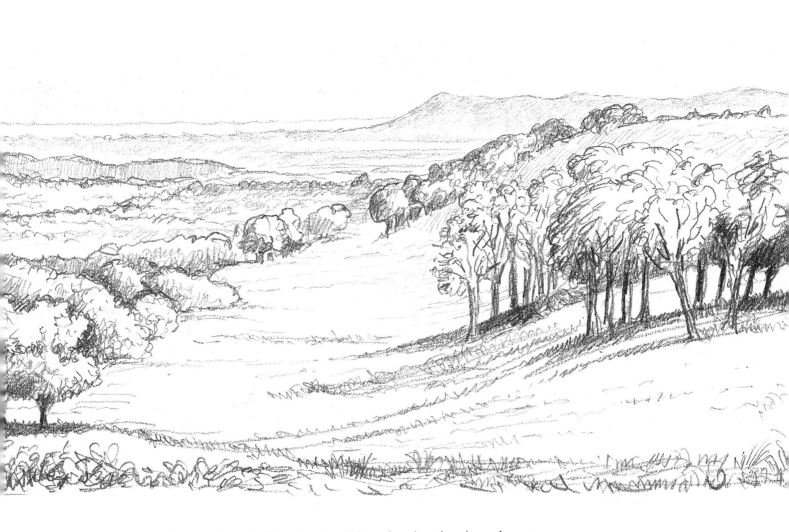

In these two examples we have (left) a stretch of river drawing the viewer's eye
into the scene and (above) a stretch of open countryside pulling the attention
to the distance of a wooded hilly landscape. Both devices are there to draw
the viewer into the picture, with the masses of trees on each side acting as
directional movements through the scene, enclosing our view. In the river scene
the reflections on the water play a prominent part in attracting the viewer's eye,
whereas in the other the mere open space in the centre of the composition
is the place where the eye comes to rest. Though the river scene is a shorter
view, the distance between the banks narrows as the river recedes from
the viewer; in the landscape above, the perspective effect of the converging
trees on each side of the open ground is more marked.

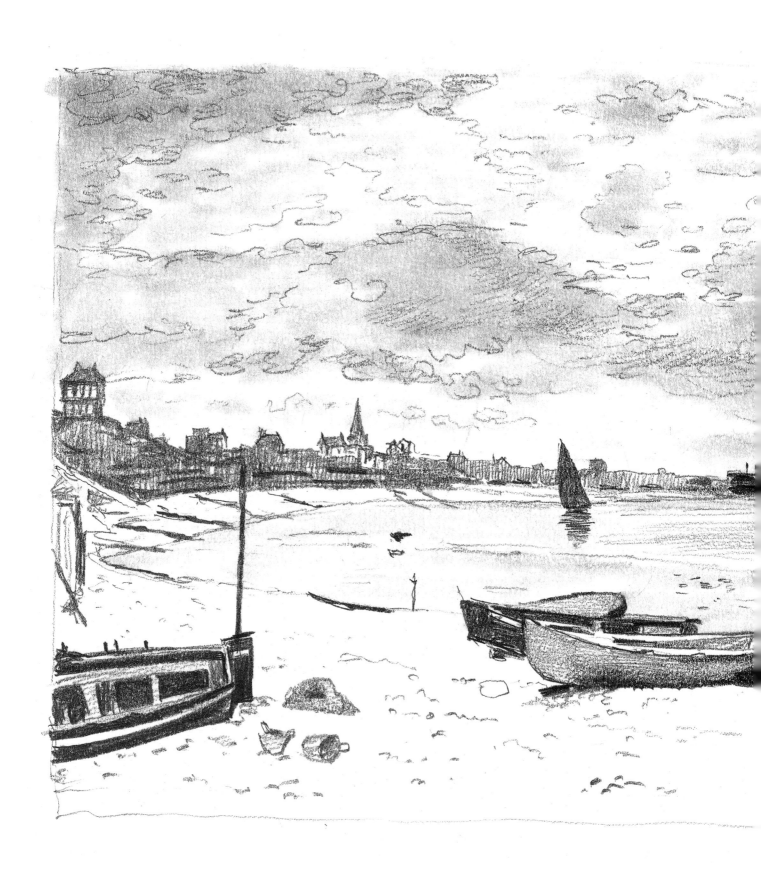

On the left is a version of a Claude Monet (1840–1926) painting of a beach, from which I have removed all the people to show how the landscape itself takes your attention from the foreground, sweeping away around the bay to the distant horizon of the sea. The boats drawn up on the shore in the immediate foreground grab the attention first and as the coast leads the eye around we see the middle-ground dinghy and then, in the far distance, what appear to be more sails out at sea. The sky in this composition takes up half the space and is important, with its dappled cloudscape making a contrast to the lower half.

In the landscape below the main theme is the avenue of trees along the road, taking the attention of the viewer into the centre of the picture and disappearing into the dark clouds covering the lower parts of the sky. In this picture the stormy sky in the background is in fact the element that is brought to your attention by means of the avenue leading into the distance.

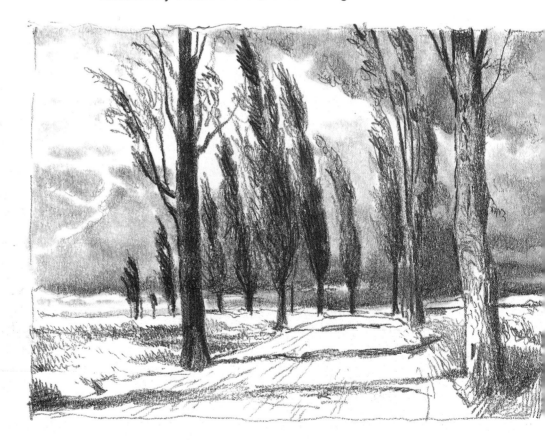

The next three pictures show examples of scenes where a path or waterway draws the eye into the scene by leading away from the foreground into the distance. This very effective device is often used by artists to add interest to the picture.

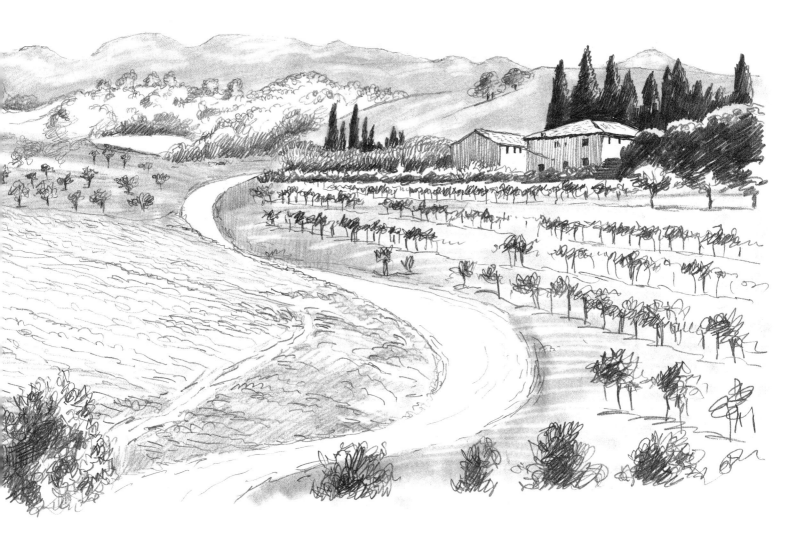

In this view of the Chianti countryside in Italy a path winds across the scene past the open vineyards and a farm, disappearing into the hills. Nearly all the main features are on the right side of the picture, but they create a horizontal thrust across the scene, counter to the direction of the path.

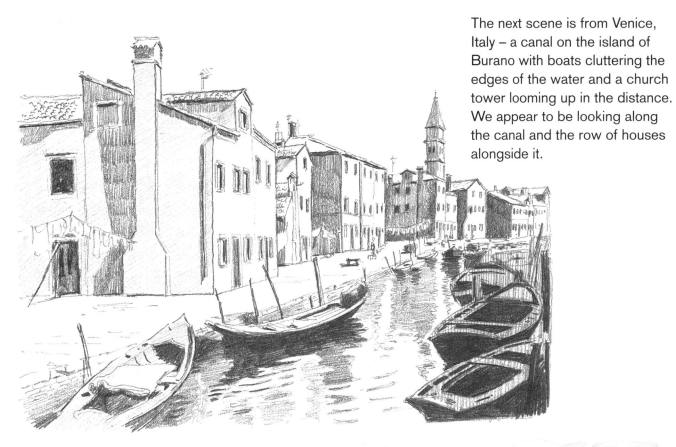

The next scene is from Venice, Italy – a canal on the island of Burano with boats cluttering the edges of the water and a church tower looming up in the distance. We appear to be looking along the canal and the row of houses alongside it.

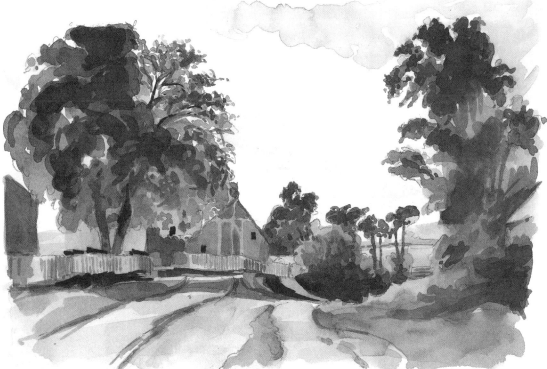

This watercolour by de Wint shows a lane dipping past a farmhouse in the Warwickshire countryside in England, where we appear to be on top of a slope. The large clumps of trees frame the whole picture in a satisfying way.

71

Drama, form and grandeur

A dramatic landscape is always a good spur to making a drawing, whether it is mountainous or watery, natural or manmade. You can emphasize the power of the scene by using strong tonal contrasts and angled viewpoints.

Here I have drawn the viaduct bridge over the River Wear in Devon, which combines awe-inspiring architecture with beautiful countryside. This sort of landscape is dramatic from many angles, but I have chosen the most obvious to show the shape of the bridge and its reflection in the river. It also helps that the sun is behind the bridge, making it into a marvellous silhouette against the bright sky and stream.

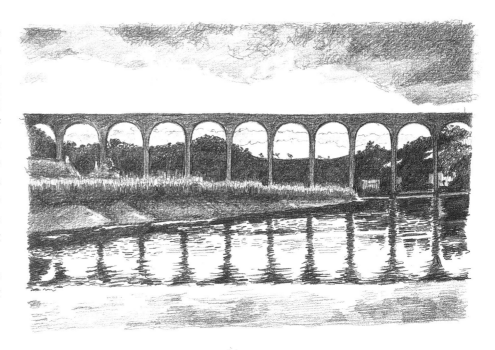

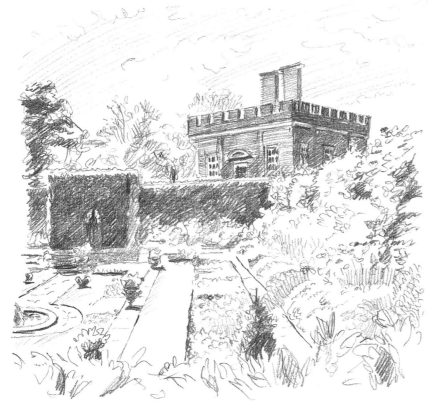

This view across the formal gardens of Hampton Court Palace just outside London is a study in gardening on a grand scale. The whole scene is a carefully composed pattern of plants and paths, with the mass of the building in the background nicely balancing the soft formality of the lawns and flowers in the foreground. Only part of the garden is shown, which stops it becoming too panoramic – what you might call a domesticated environment, but on a grand scale.

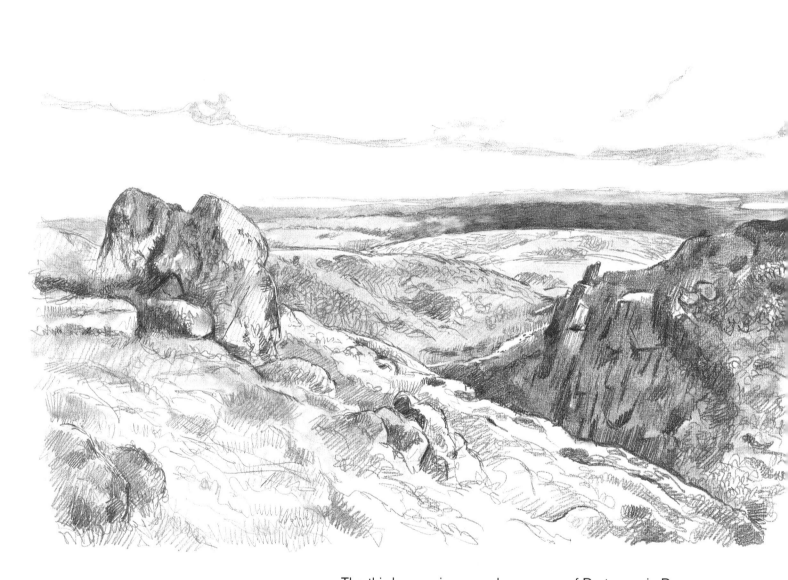

The third scene is a grand panorama of Dartmoor, in Devon, by the Victorian artist John William Inchbold. With this type of landscape you need to find a place that gives you key features to help frame the composition, which Inchbold has done well with the large rock on the left and the deep ravine on the right. The sweep of the sky is kept to about one-quarter of the whole area of the picture, so that it doesn't distract from the rugged scenery. Overall accuracy is not the most important part of a drawing such as this – capturing the atmosphere of the place comes first.

Picturesque views

Certain views can have particular attraction for landscape artists, with a pleasing arrangement of trees, hills, water or buildings that will come across well on paper. Learning to spot these features is an important part of landscape drawing.

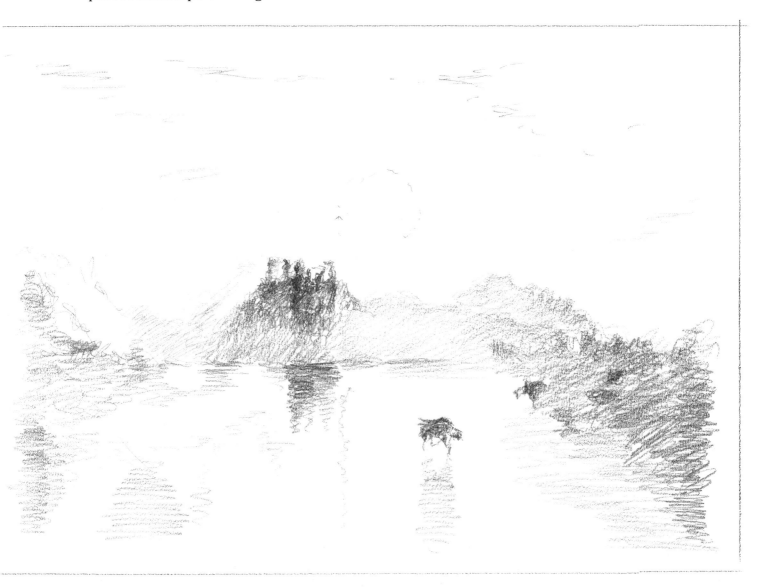

These two pictures are of examples of scenes that seem to cry out to be drawn. The first was seen by Turner, and he takes a landscape that appears to have dissolved into the sunlight. He has looked at what is actually a solid enough building, with hills around, but because of the strength of the sunlight it seems to have been diffused into the air itself. The reflected light on the water in front of the castle also seems mostly light and so the actual marks that he has made are quite flimsy. Of course he was a master of this sort of work and you will not find it easy, but it is worth trying it out some time if you can get the right circumstances. The trick is not to put too much information in the picture.

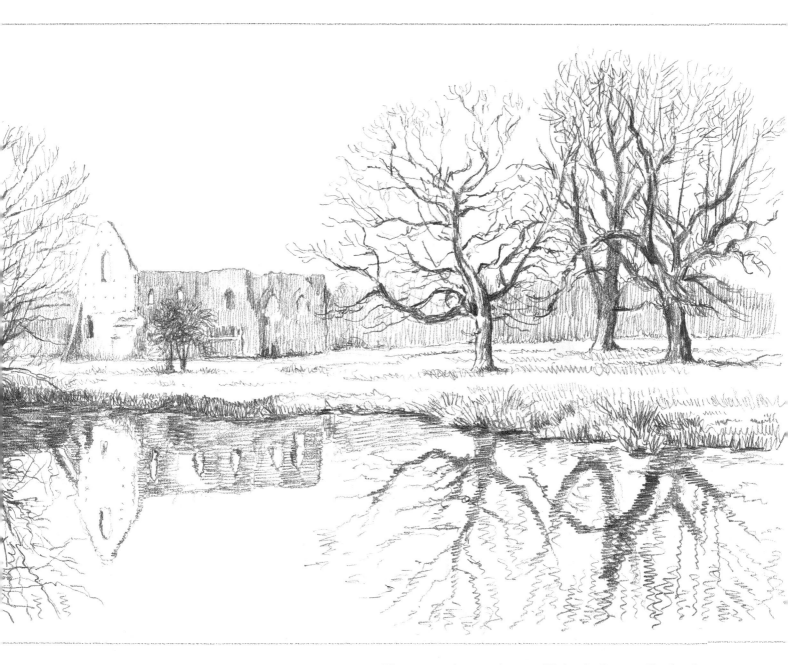

The second scene is near Ripley in Surrey, England, where I drew an ruined priory, reflected across a stream, on a still day in winter. The large trees on each side of the building are the main part of the reflection, and frame the ruin nicely. The search for picturesque, romantic sights is often what drives landscape artists.

An expanse of water

This exercise will require your total concentration and all of the drawing skills you have acquired so far. My drawing is of a small English river, in Sussex. I haven't included much landscape around it, so the only real problem is drawing the water – but this is quite a problem, partly because it is moving, as opposed to the flat surface of a lake on a windless day. I picked a very calm day so that the movement was reduced to a minimum, but even so your task is not an easy one.

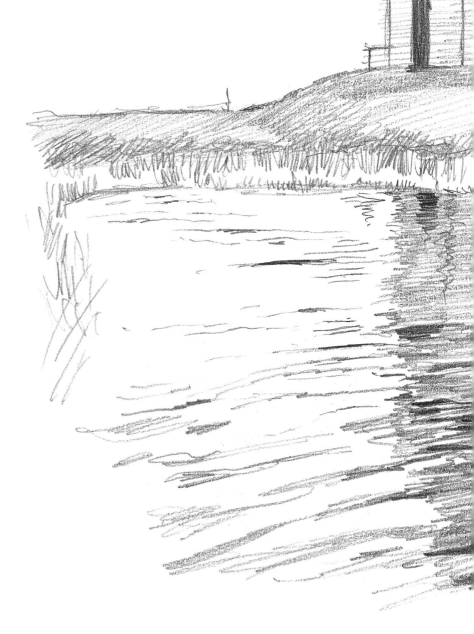

Notice how the reflections of the bank and the building upon it are making a darker tone across the surface of the water, but everything is broken up by the ripples, which reflect the light and shade in various ways. The darker tones of the larger ripples help to define the surface, so don't hesitate to put in as many of these as you can see, but show the difference between the brighter part of the water and the darker part.

Don't be afraid to put in the very darkest tones, because one of the properties of water is to reflect the lights and darks in quite strong contrasts. It will require some judgement on your part to get the right balance of the tonal values – that is, the difference between the tones from the darkest to the lightest. Take a bit of time calculating these differences – it is never wasted.

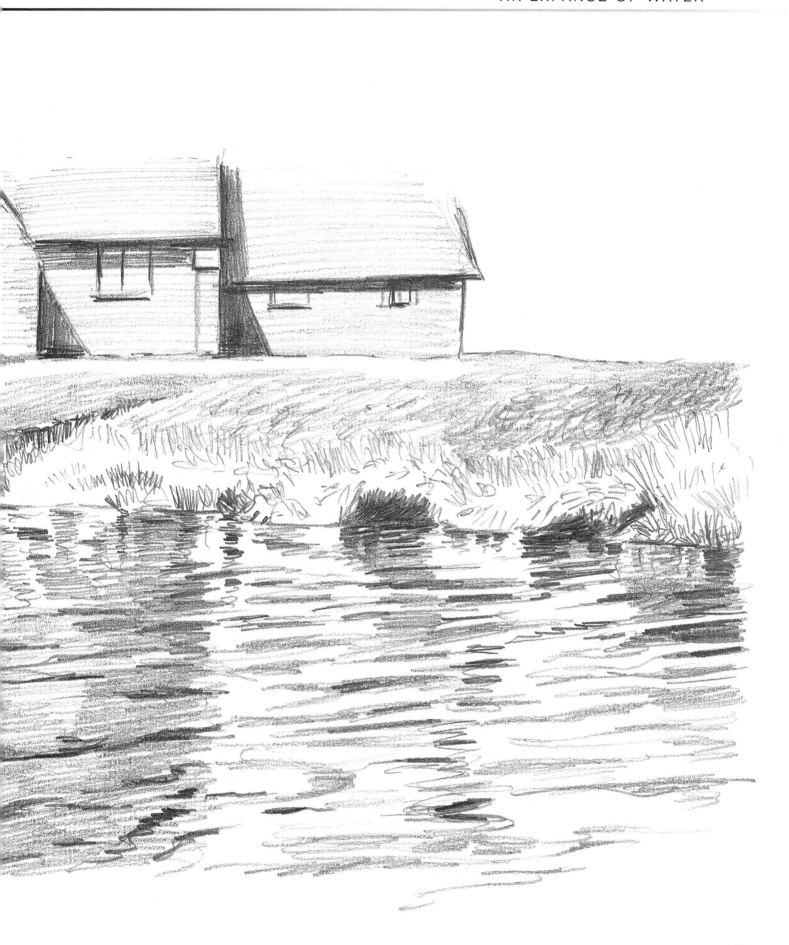

Combining water and architecture

In this exercise, you will set yourself a challenge by using your experience of drawing water and architecture in one scene. This may entail some planning on your part in order to find the right spot; I am lucky to live close to the River Thames, so there is plenty of choice for me in this respect. I picked a view of Hammersmith Bridge, which is in an urban area, so there is plenty to draw.

You will notice that the bridge itself is of such an interesting design that it almost stands as a great piece of architecture on its own. The huge suspension curves of the steel structure that supports the roadway over the river are held by two massive arched towers at each end.

I started by drawing in linear form the main structure that I could see and the line of the water with the edges of the main dark reflections. The darkest parts were underneath the bridge itself, so they help to give the bridge strong definition. Then it was simply a matter of carefully putting in all the texture and construction of the bridge first and adding the background and water effects after.

The very strong shadows on the main parts of the bridge and the deep shadow below it create a very strong and interesting image. The water was as difficult as ever, but because I had opted to draw only a narrow part of the further shore it wasn't quite the problem it might have been.

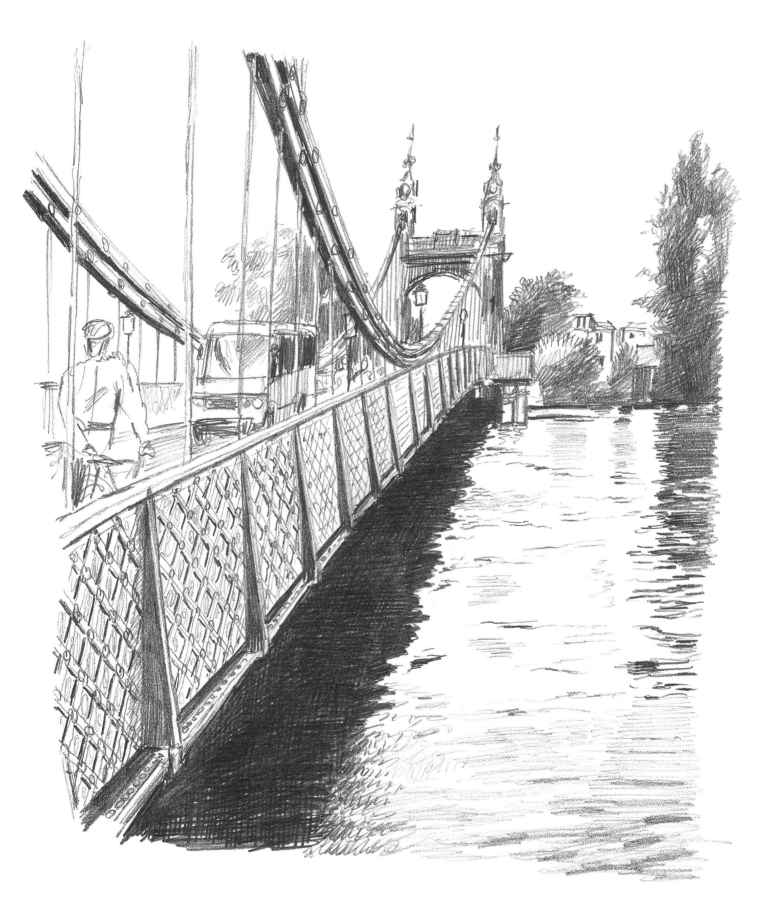

Choosing your format

When it comes to drawing landscapes the usual tendency is to think in terms of a wide horizontal shape, which is indeed known as landscape format. However, a vertical shape (portrait format) can sometimes be an interesting variation that may suit your subject better. Shown here are three versions of portrait-format pictures that show how this way of selecting your scene can be useful.

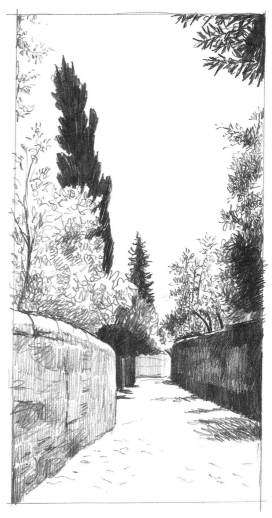

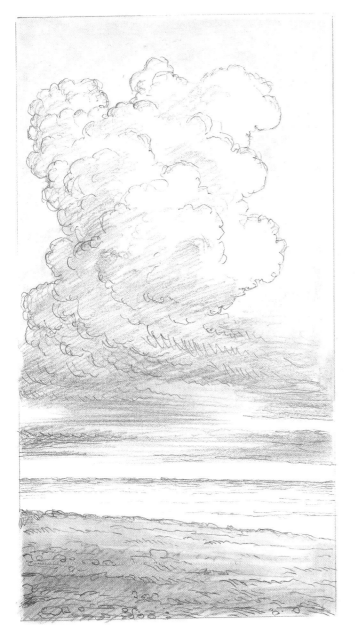

The first scene is of a narrow walkway near Florence, Italy, which shows tall trees each side of a walled road. The whole interest of the picture is the perspective effect of the tunnel through the encroaching walls and trees. If you were standing in this spot it would be obvious that a portrait format is the way to draw the scene.

The next drawing is a much more selective view, because the natural way to portray an open beach scene without much in the way of foreground features is to show it in a wide horizontal format. Here, with the sides of the picture pulled in, the magnificent cloud is the main feature; the sea and beach have been reduced to the minimum so as not to distract from the view of the sky. This sort of landscape could correctly be described as a skyscape instead.

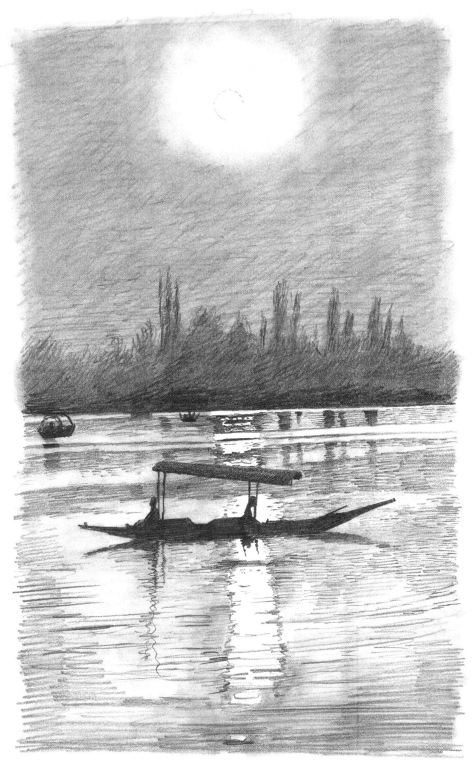

This scene was drawn very late in the day when the low sun was making silhouettes of the boats and trees. It's more a picture of the sun and its effect on the misty sky and the water rather than of the lake itself, so the portrait format was used to act as a window that selects the sun and its reflection. The passing boat in the centre of the scene is a bonus, only made possible by using photographs for information; a moment such as this doesn't allow time for detailed sketching.

A panoramic view

This picture of downland scenery to the south of London was drawn in the 18th century by George Lambert. He chose a wide format to include as much of the panorama as possible, positioning himself well back from the hill – he even shows another artist in front of him drawing the scene. It is clear he wanted to place the hill dead centre in the drawing, framing it with trees on each side of the picture. Many artists of the time would paint large panoramic views like this and then charge the public a small fee to see them.

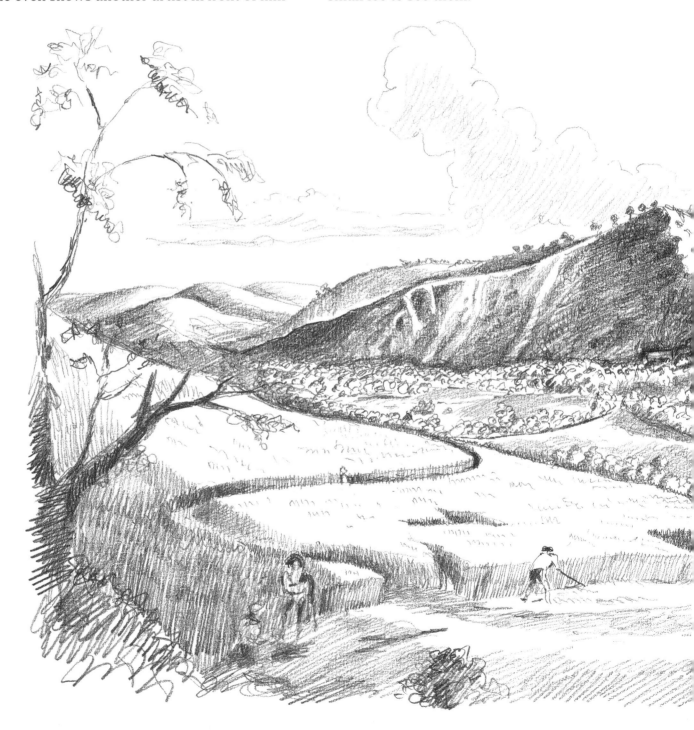

Tackling a panorama

When you feel ready to have a go at a complex large-scale picture such as this you will need to set it up carefully. You will obviously have to choose a day when the weather is going to be in your favour, and then you will have to find a spot to draw from that makes it easier for you to encompass the whole scene. It's a time-consuming subject, too, so you'll have to allot a good part of the day to your drawing, or else return several times in order to complete the picture. Again a good series of photographs will help to add extra information for completing the piece when you get it home.

Working on a piece this large is always a challenge, but if you have the courage to try it out you will probably learn a good deal about landscape drawing in quite a short time. If the view is local to you, visiting it repeatedly beforehand will tell you a lot about the times of day the light is most attractive and the best spots to place yourself. It will also help you to regard the scene as a familiar one, making the moment you arrive with your paper and pencils less daunting.

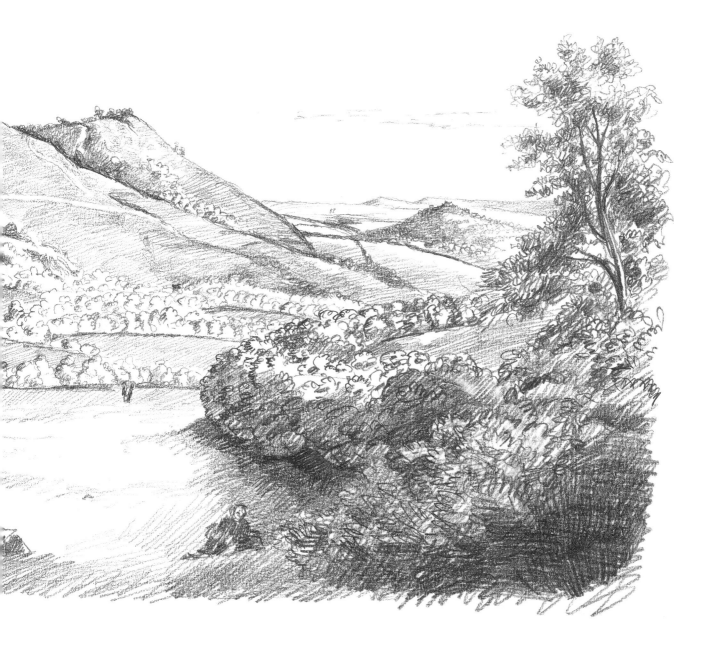

Framing your scene

When starting out to draw a landscape, one thing that is very useful is a carefully cut window frame shape, roughly the same size as the paper that you are going to draw on.

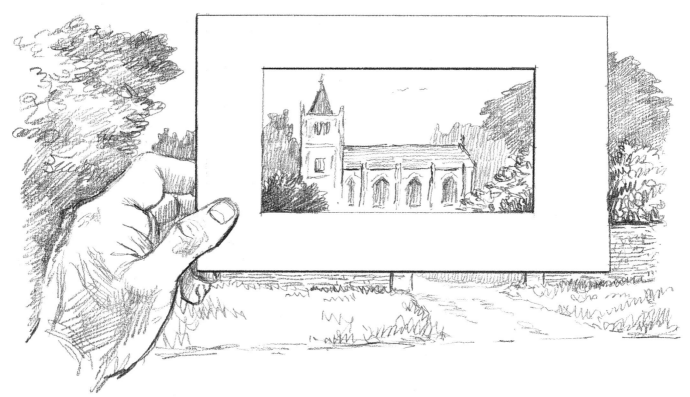

As you can see in this drawing, the size of your frame should be big enough to get a reasonable aperture, but not so big that it is difficult to handle. You can make the frame out of card for longer-lasting quality, but stiff paper is usually good enough.

The framing device helps you to select from the amazing mass of information that your eyes normally see, and decide exactly how much of the landscape you want to draw. This decision is crucial to getting a good result, and with practice, it is possible to make your selection without the framing aid. But it is a good idea if you are a beginner, and even professional artists use one sometimes.

Exploring landscape

This project is intended to get you thinking about how you might start on your own landscape composition. I took a short trip to a wetlands nature reserve beside the River Thames in south-west London. The environment is especially dedicated to the flora and fauna of watery and marshy places, so although it isn't quite wilderness, it has a natural feel.

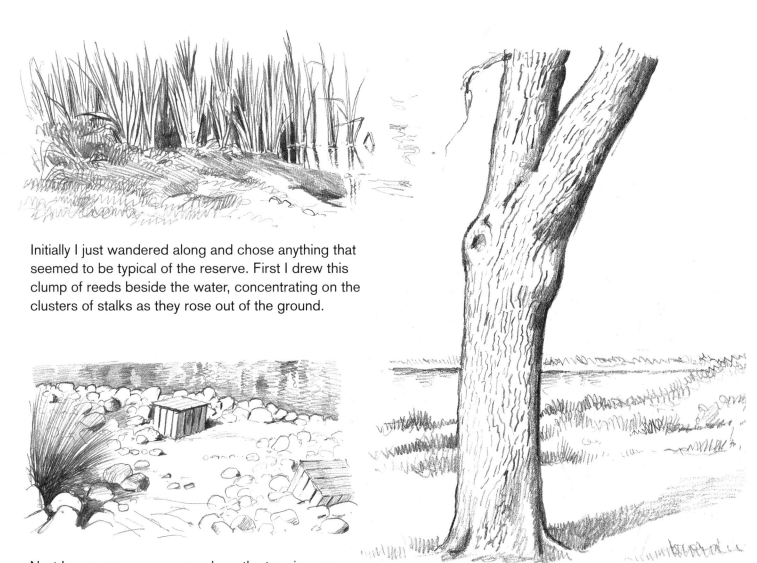

Initially I just wandered along and chose anything that seemed to be typical of the reserve. First I drew this clump of reeds beside the water, concentrating on the clusters of stalks as they rose out of the ground.

Next I came across an area where the terrain was mainly lumps of rock and stones, with a few boxes for nesting purposes and some reeds – quite a different feel to the previous scene.

Then I concentrated on the bark of a tree that was near the water. All these exercises got me into the experience of drawing in this type of place, with its varying forms and textures.

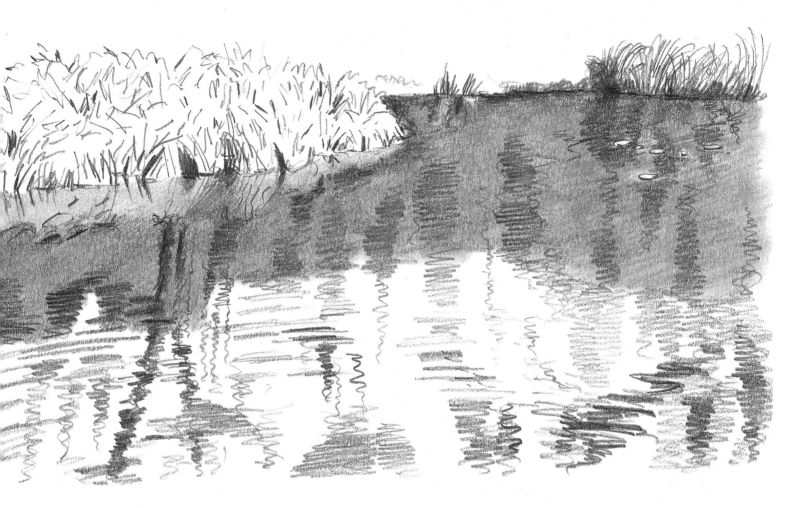

Then I decided to try out two examples of water, getting a feel for the texture of its surface and how the reflections appeared when seen in different lights. The first, which is a sheltered spot of water, has many reflections that are distorted just a little by the ripples.

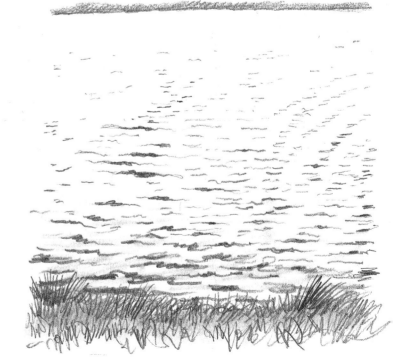

The other stretch of water was more open and had many ripples across the surface, but because of the angle at which I was viewing it there wasn't much in the way of reflection.

Next I began to consider the scene as a whole. Using my framing device to select a view, I drew this little wood cabin with trees around it and a path leading up to it from a bridge over the stream. There's a slightly more solid, hard-edged look to the scene.

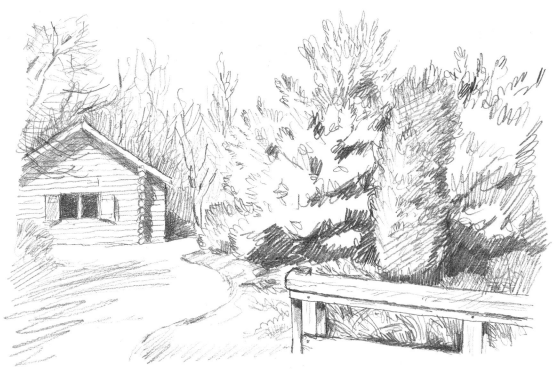

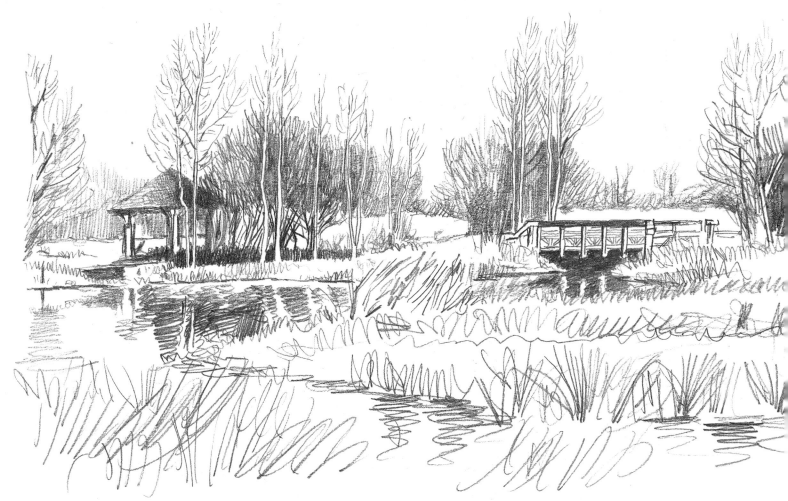

Then I looked at this rather more open expanse of stream and small trees, where there was another small shelter and a wooden bridge. The myriad streams threading through the landscape are more obvious here.

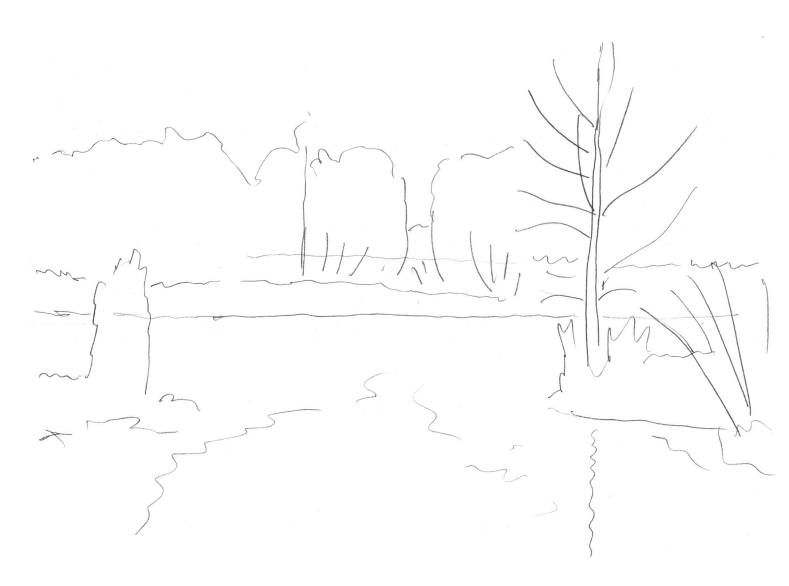

Finally I decided to opt for this view across an
expanse of stream with many silver birches and other
marsh-loving trees scattered along the banks. At first
I sketched in the main areas of the composition very
simply so that I knew how much I was going to take on.

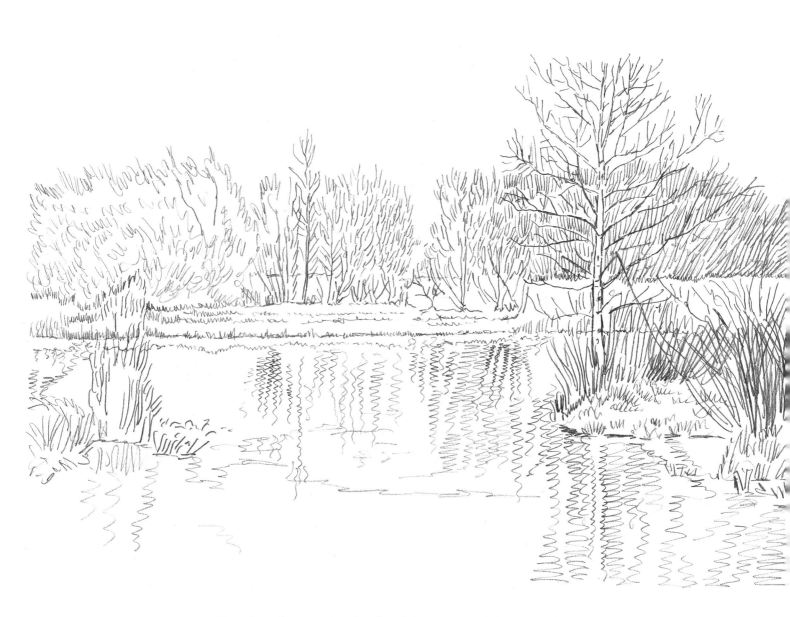

Then I worked up the details of the trees and the water in
a linear fashion so that I had the whole scene drawn up
clearly and could make any alterations as I felt necessary.
The water was drawn with zig-zagging marks to indicate
where the deeper reflections were on the water.

To finish the drawing I carefully put in the tonal values so that the water and trees began to show more depth and spatial qualities. This is quite a simple scene in terms of composition, but the flimsy quality of the winter trees where I could see through their branches was quite a challenge – a very light touch was needed. To achieve the smooth tonal quality of the water I used a very soft pencil (7B) and smudged the marks with my finger.

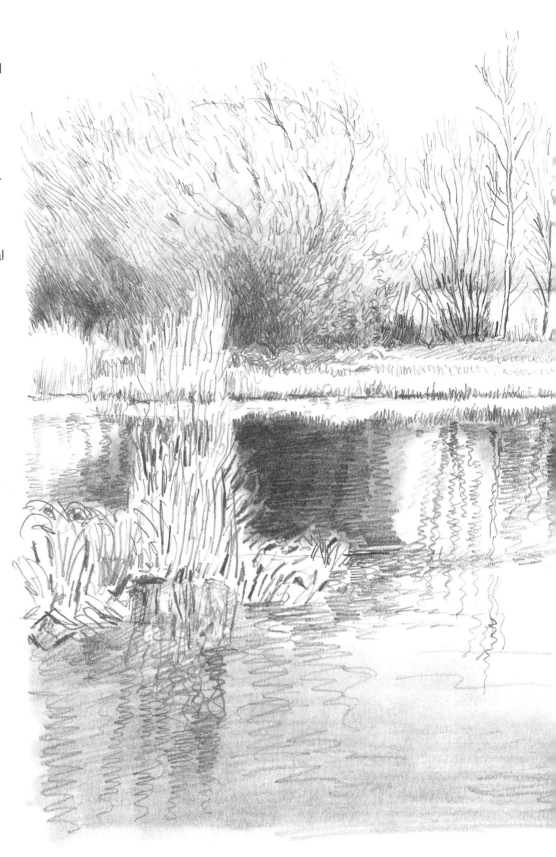

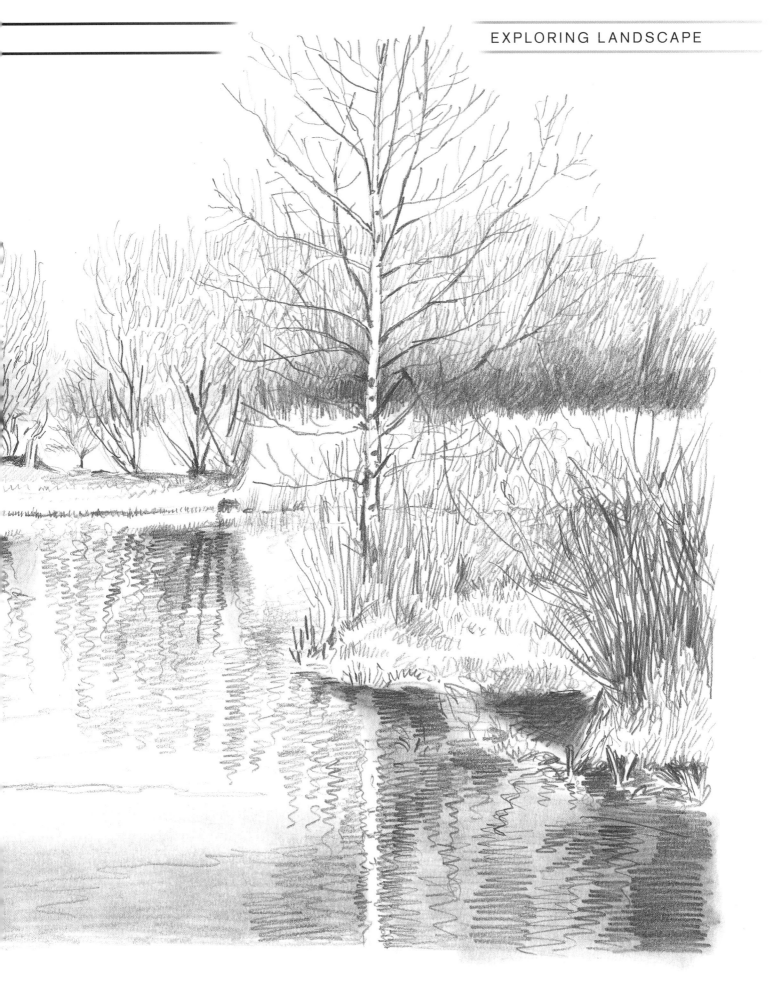

Master examples

This example is a picture of Pegwell Bay by William
Dyce, a Victorian artist. Here the composition is a
very simple halfway horizon with a range of chalk
cliffs jutting into it. All the action in the picture is in
the lower half, with various areas of rock and sand
on which people are gathering shells and so forth.
Most of the significant action is in the immediate
foreground. The ladies in their crinolines make
pleasing large simple shapes.

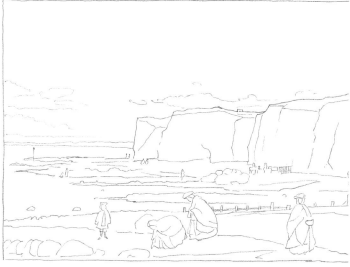

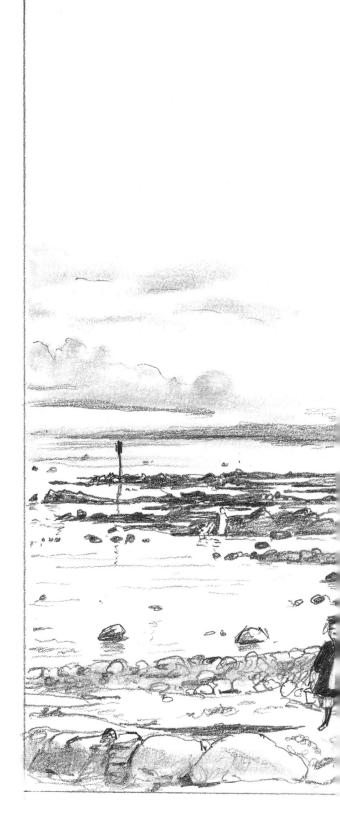

Draw out the scene in outline and then put in the tone. In
this picture it is fairly even and light, so you can probably do
most of it with linear marks.

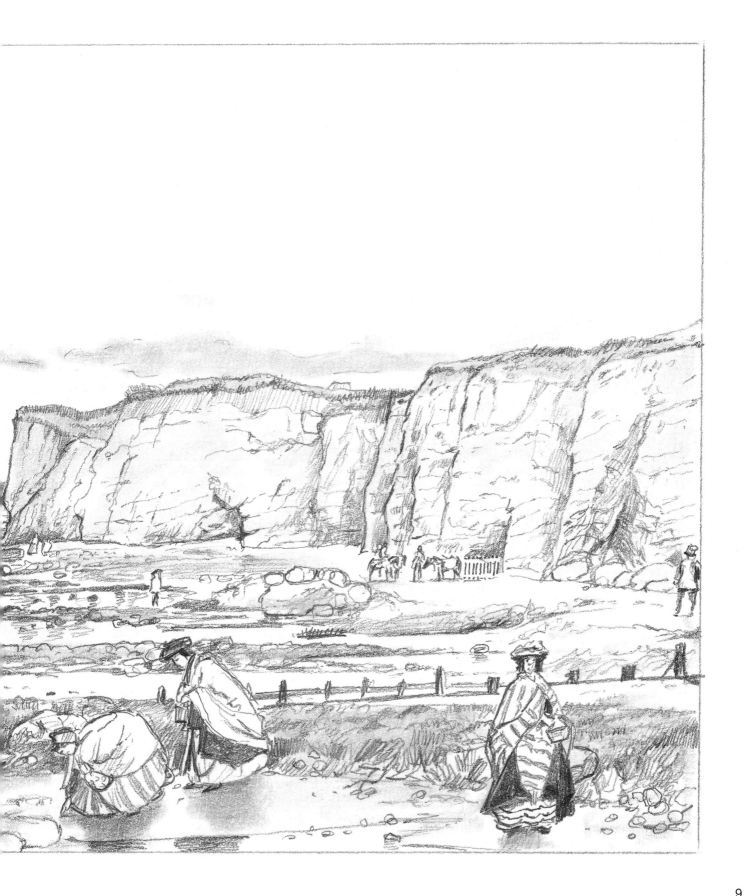

Next, a work by Richard Wilson (1714–82) of the top of Cader Idris in Wales. This design is mainly a large triangle, broken by the curve of a lake and the sweep of more mountain to one side. The curve is repeated twice in a mound below the lake and another body of water lower down to the left.

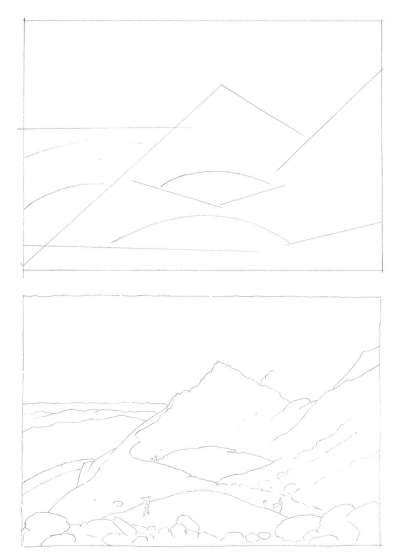

Because of the dramatic view, the tones are important as they show the sharp triangle of the peak above the lake, silhouetted against the sky. Have a go at copying this scene – it will teach you a lot.

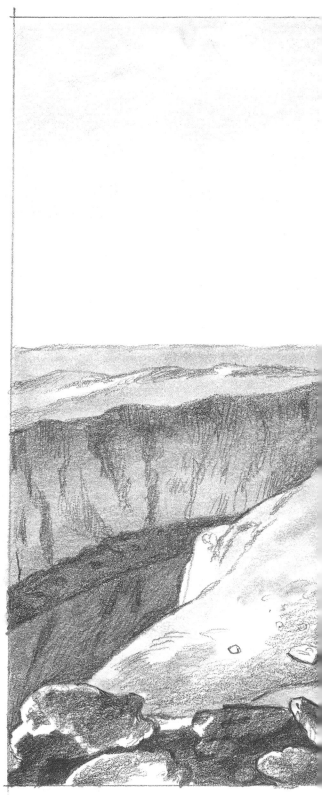

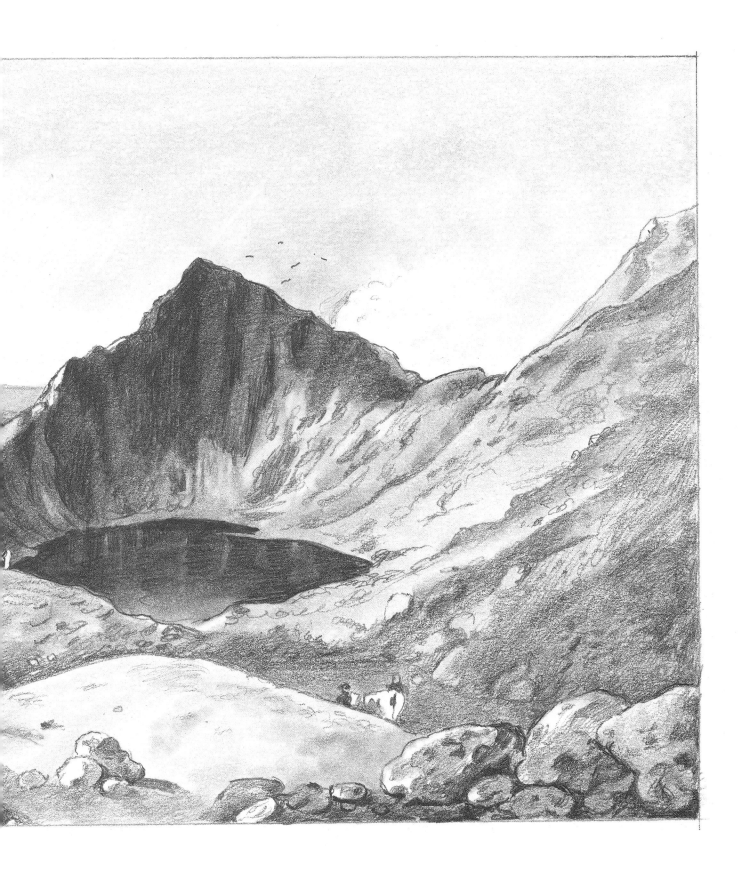

These two compositions are after the Viennese painter Gustav Klimt (1862–1918), who specialized in decorative effects. They complement each other. The first has most of the scene made up of the grassy foreground, while the other is composed mainly of the massed leaves of the trees. Klimt tended to reduce the depth of his paintings to flatter, more abstract areas of texture, and in the first example the large area of grass is given a little depth only by the spaced silver birch trees and the mass of dark trees in the background.

Here the mass of the background trees becomes the main area of the composition, while the foreground and middle ground are squashed into a very small area at the bottom. These effects give quite a dramatic quality to the landscapes, and the texture of the grass and leaves in both is treated in a very decorative way.

Week 5

The animal world

Drawing animals is not unlike drawing human figures in that you will find yourself dealing with the same issues of getting the proportions correct and showing foreshortening where the angle of view demands it. The major difference, of course, is that you won't be able to persuade any animal to stay patiently in a pose you choose. Indeed, many won't remain still long enough for you to manage any more than a quick sketch. This means that you have to start drawing quickly and go for only the most obvious shapes first, even in the case of a sleeping animal, as most tend to move quickly once awake.

This is an area of drawing where photography is particularly useful, especially for supplementing swift sketches done at the same time. Taking photographs of the animals in similar poses to the ones you have tried to capture will give you the information to do a more finished drawing. However, it's probable that to familiarize yourself with drawing animals you will have to start by resorting to books or magazines that give you either detailed photographs of animals or drawings by artists who have specialized in the subject.

It is never wrong to copy more accomplished artists, since this has always been the traditional way to learn how to draw – in Renaissance studios, the masters would keep drawings in sketchbooks that were used by their assistants to inform their own drawings and paintings. Do try drawing from other sources as well as directly from life so that you can get a good deal of practice in picturing animals.

Sketching from photographs

You may have heard that artists should always draw from life rather than from photographic references, and it's true that relying entirely on photographs is not a good way to proceed. However, used judiciously, they are more of a help than a hindrance, especially where you have a constantly moving subject. The problem only comes when you slavishly copy them and produce drawings that lack the animation and freshness that comes from working from life, in the belief that exactitude is all that matters.

If you already have books with large, good-quality pictures of animals in them you are ahead of the game. If not, try your local bookstore or indeed your newsagent, which is bound to have some magazines dedicated to household pets, horses, wildlife and so on. Local museums and nature reserves often have books and magazines with animal pictures in them, too.

Choose some photographs that aren't too challenging in their angle of view and start by keeping your drawings very simple, putting in only the main shapes. These examples are just to give you an idea how that can be done. Notice how the penguin is a very simple elongated pillow shape, with a beak at one end and feet at the other. The owl is even simpler, characterized by its big eyes. The giraffe is an elongated angular shape, with a very long neck and legs related to the size of the body. The rhinoceros, on the contrary, is a very compact shape, with just the addition of the jutting square head and the legs.

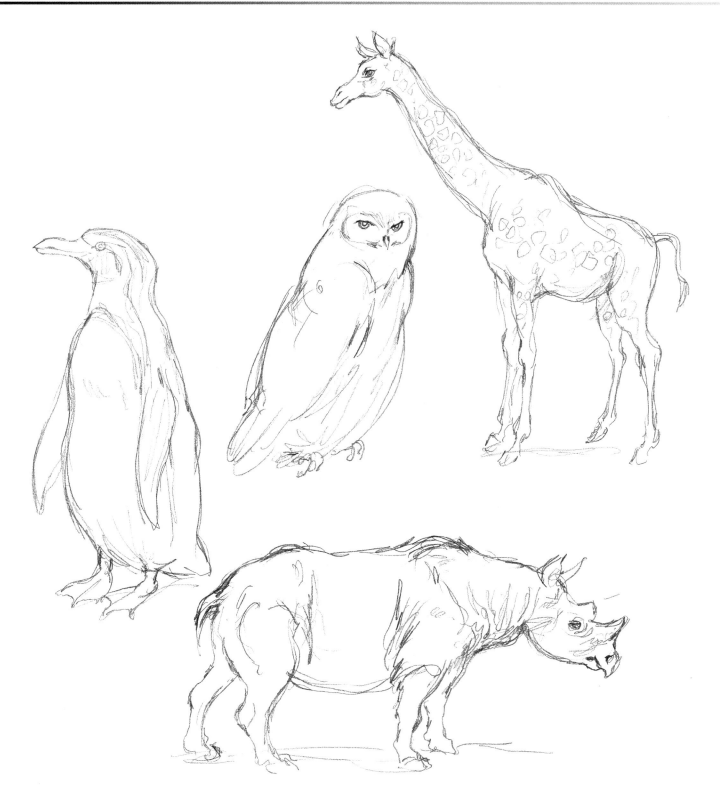

Now have a go at drawing in more detail and allow the line of your pencil to follow the obvious contours and patterns of the animals. Don't worry about a great deal of naturalism at this stage – just concentrate on getting the feel of the animal's shape in a sympathetic way, roughly indicating the texture of skin, fur and feather with your line as you do so.

Drawing from life

The next step is to draw animals from life, encouraged by the confidence you've gained by working from photographs. Most of the time you won't be able to complete your drawings, not least because many animals will move away as a result of your showing too much interest in them for their comfort. However, domesticated animals can usually be observed when they are sleeping or just relaxing, and this is an ideal opportunity for you. Even so, it's a good idea to take a quick photograph so that you still have some reference if they decide to go.

Birds

I've started with birds because although they aren't often motionless, they have fairly straightforward shapes and can be drawn quickly. Once again, go for a very simplified drawing first as I've shown here, so that even if they move you have got something down on paper. Taking a quick look and remembering what you saw is a very good discipline.

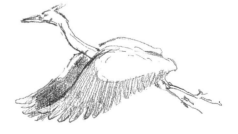

If you get the chance, put in as much detail as you can, taking your own photographs to help you remember. Tone can often be the way to help show the substance of the animal.

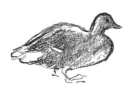

Cats

Domestic cats are very useful models as they are very somnolent – most sleep for about 16 hours a day. Consequently, you should have plenty of time for fairly detailed studies and because of their furry coat and relaxed, graceful forms they tend to present easy, fluid shapes to draw. Draw the main shape of the pose in a very simple way, as you can see in these examples, and add the heads and legs to that.

Next, show the texture of the fur with multiple strokes of the pencil. Indicating the coat markings will make the drawing look much more like a portrait of that particular animal. The eyes and nose are important, and as they are very close to each other you shouldn't find it too difficult to see the right proportions.

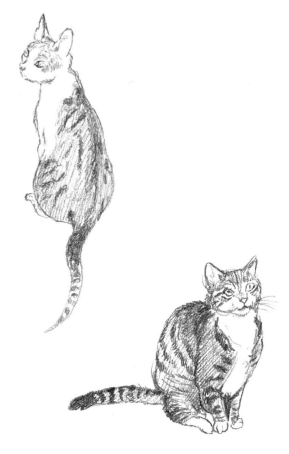

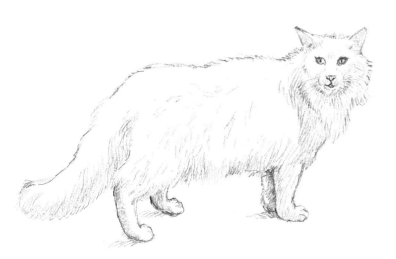

When you feel confident enough, have a try at more active animals and see how far you can take the drawing. Go for the main outline first and then as much as you can include in the time you've got.

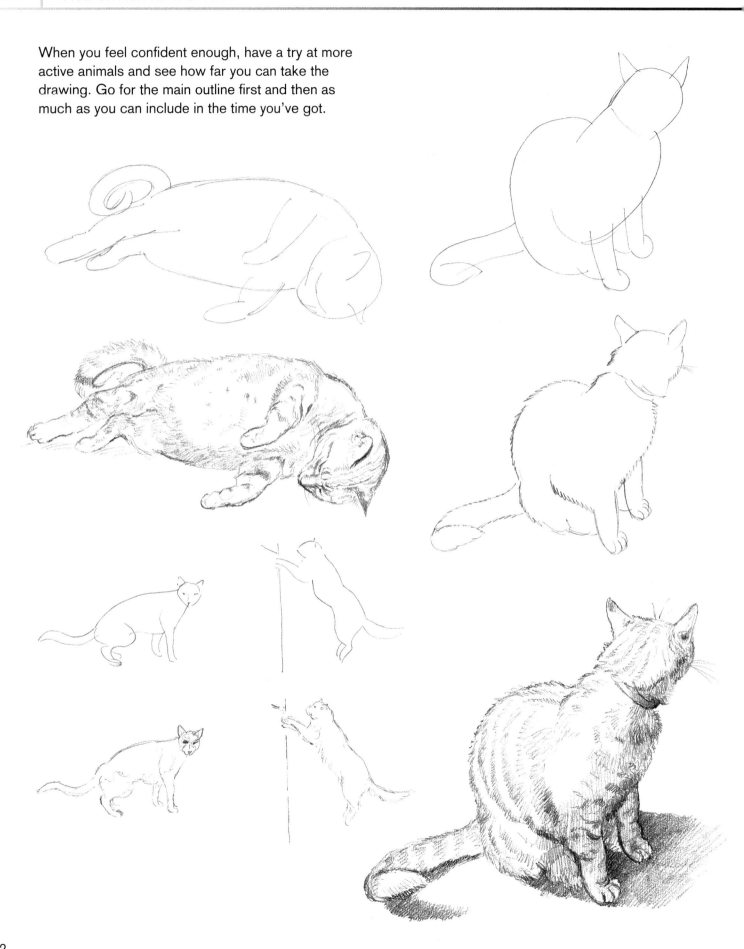

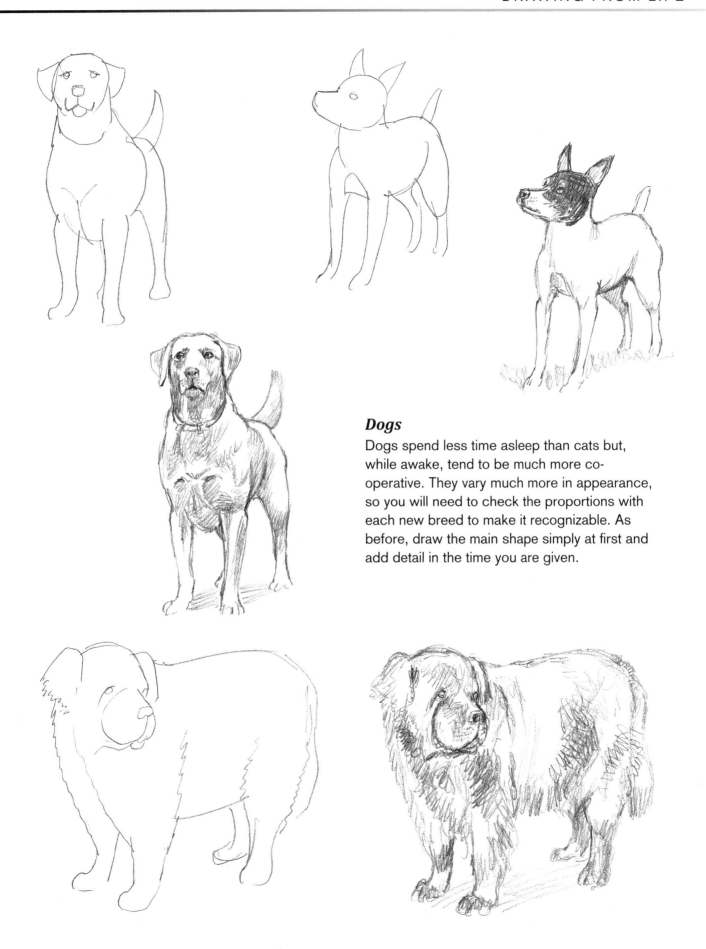

Dogs

Dogs spend less time asleep than cats but, while awake, tend to be much more co-operative. They vary much more in appearance, so you will need to check the proportions with each new breed to make it recognizable. As before, draw the main shape simply at first and add detail in the time you are given.

Farm animals

Have a go at drawing farm animals if you are in the countryside, or even in town if there is a city farm near by. Luckily sheep and cows don't move too fast, and they keep adopting the same poses. Again, note the different characteristics belonging to the breed rather than just reproducing your idea of what a cow or sheep should look like. Practice makes perfect, so keep your sketchbook with you wherever possible and even if you have only two or three minutes to do a thumbnail sketch it is still excellent drawing practice.

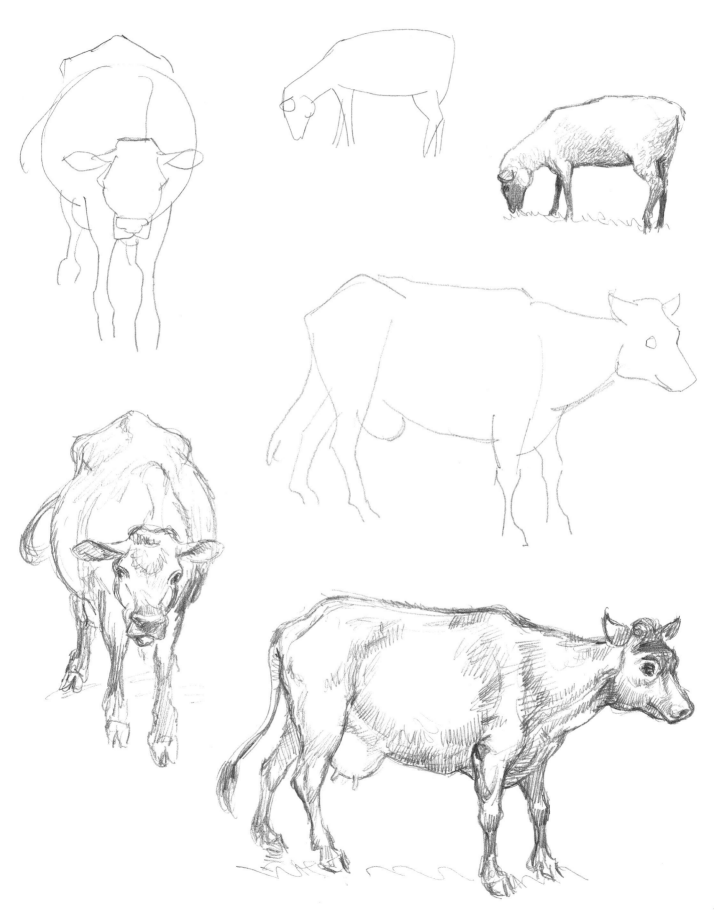

Horses

Along with large farm animals like cows, horses are probably one of the easiest large animals to find for drawing from life. You may have to return to drawing from photographs for this exercise, but if you are near a stables, do take the opportunity to draw from life as much as you can. Drawing horses from life is not too difficult but they do gently move around, and so most of your drawing will resemble the first two sketches shown below. However, after drawing several sketches like these you may be able to get some more detail as the horse takes up similar positions.

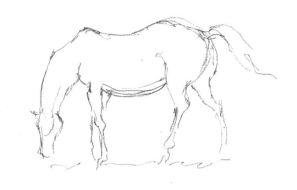

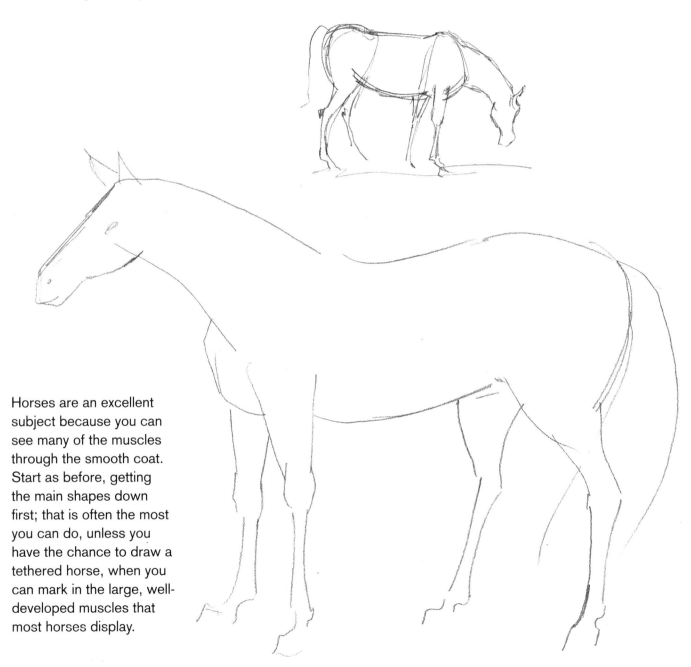

Horses are an excellent subject because you can see many of the muscles through the smooth coat. Start as before, getting the main shapes down first; that is often the most you can do, unless you have the chance to draw a tethered horse, when you can mark in the large, well-developed muscles that most horses display.

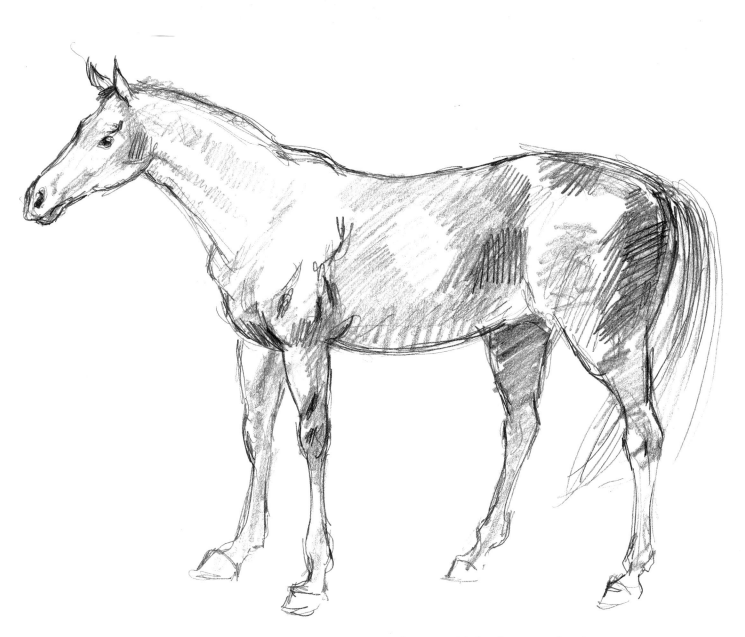

As you add detail to your drawing,
don't be afraid to mark the muscles
in strongly and quickly – you can treat
them with a greater degree of subtlety
when you are more practised.

A horse's prime motivation is to graze, so you should have no difficulty in sustained studies of them doing that – it's an alert pose with the head up that you have to be fast to capture. Photographing them at the same time gives you extra information that you can add to your drawings later.

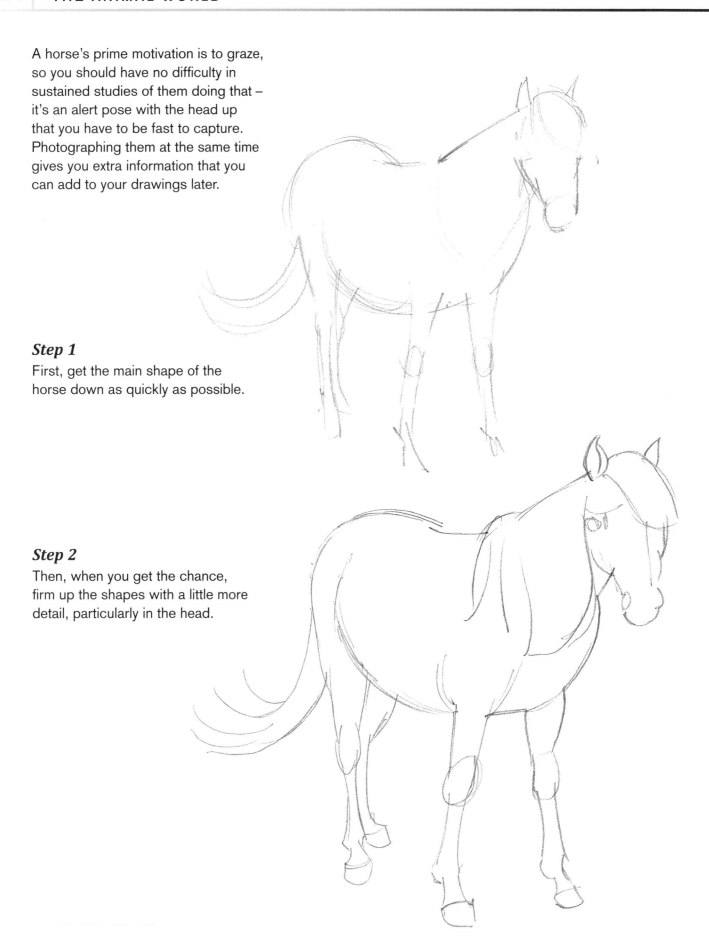

Step 1

First, get the main shape of the horse down as quickly as possible.

Step 2

Then, when you get the chance, firm up the shapes with a little more detail, particularly in the head.

Step 3

Finally, add some details of tone and texture to help give a more solid look. Some areas, such as between the legs near the chest and on the ears and nose, can be put in more intensely to contrast with the lighter areas on the horse's flank.

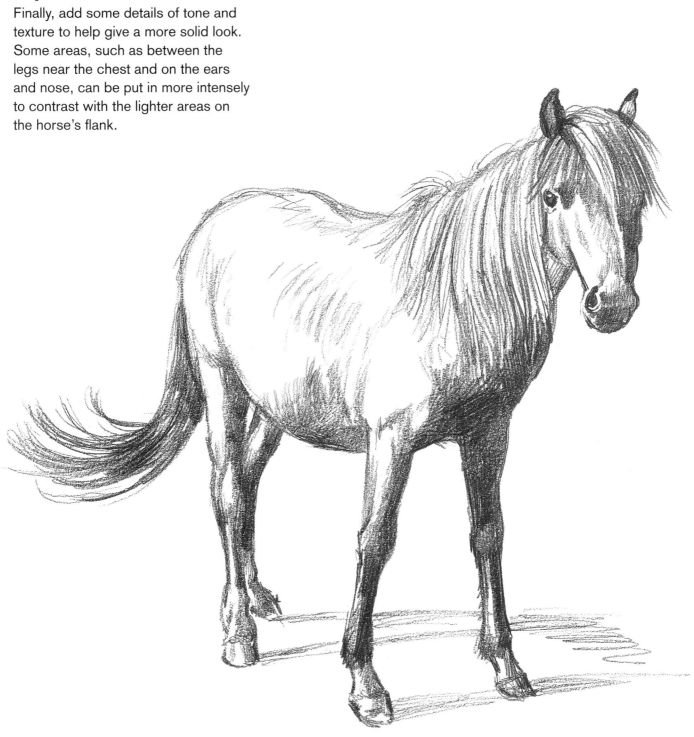

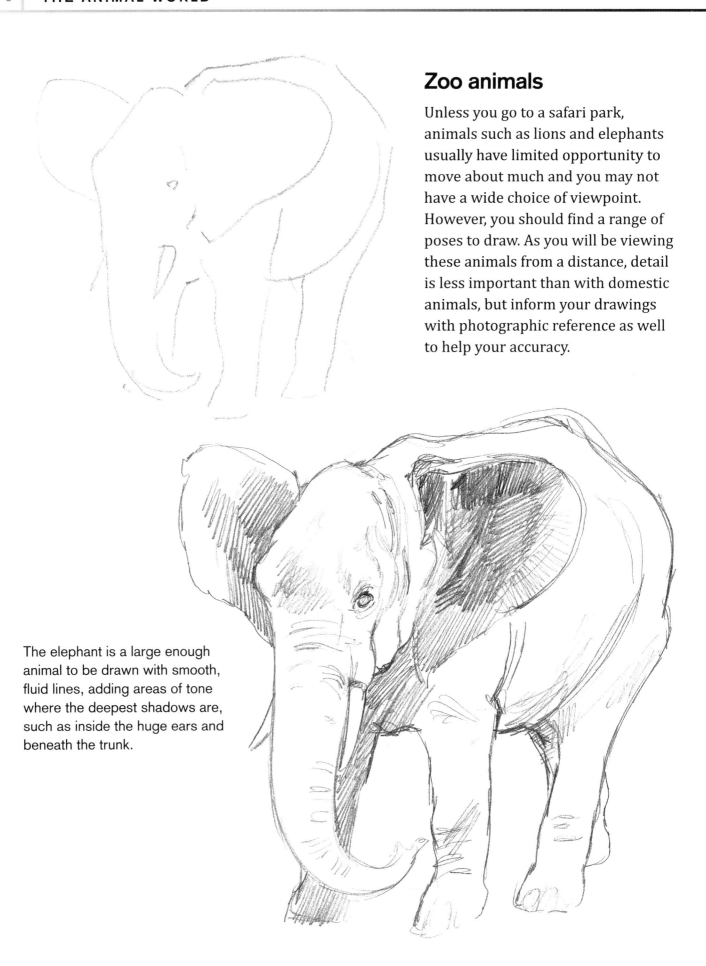

Zoo animals

Unless you go to a safari park, animals such as lions and elephants usually have limited opportunity to move about much and you may not have a wide choice of viewpoint. However, you should find a range of poses to draw. As you will be viewing these animals from a distance, detail is less important than with domestic animals, but inform your drawings with photographic reference as well to help your accuracy.

The elephant is a large enough animal to be drawn with smooth, fluid lines, adding areas of tone where the deepest shadows are, such as inside the huge ears and beneath the trunk.

Once again, draw the main outline shape, before the animal moves too much. Even if you are working from photographs, use the same method.

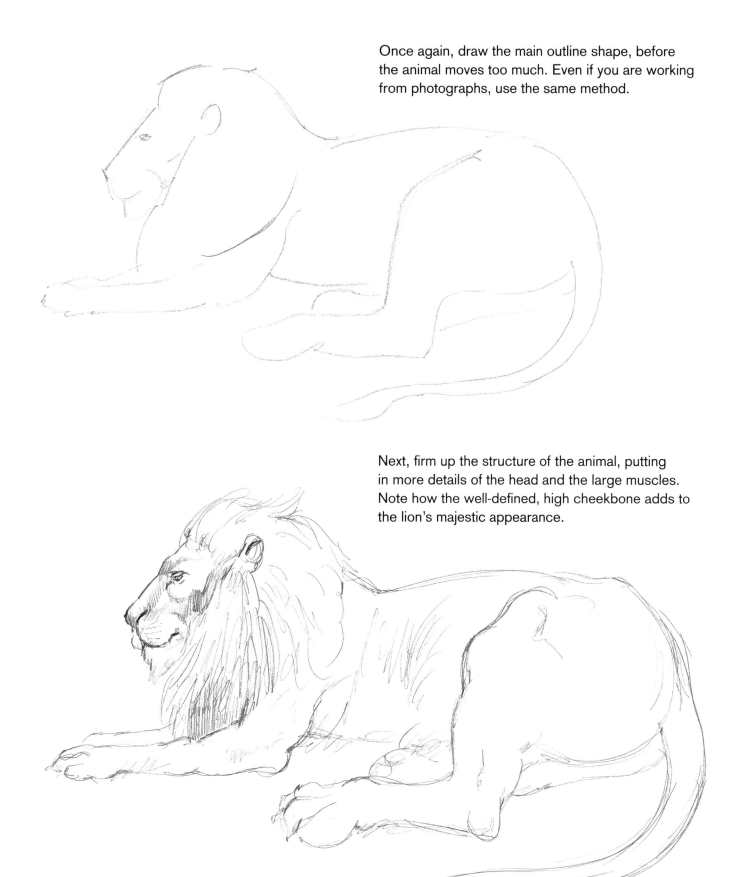

Next, firm up the structure of the animal, putting in more details of the head and the large muscles. Note how the well-defined, high cheekbone adds to the lion's majestic appearance.

Herds of animals

Drawing animals in larger numbers may strike you as harder at first, but in fact it can be easier. One of the most significant things about herds and flocks is that all their members share the same habits, so when one moves out of a pose that you are drawing another will conveniently adopt a very similar position, giving you another chance to complete your work.

Sheep are fairly slow in their movements, and among the most docile of your models. Deer, on the other hand, are rather nervous of people getting close to them, but because you will have to draw them from some way off you will more easily be able to reduce their shapes to the simplest formula.

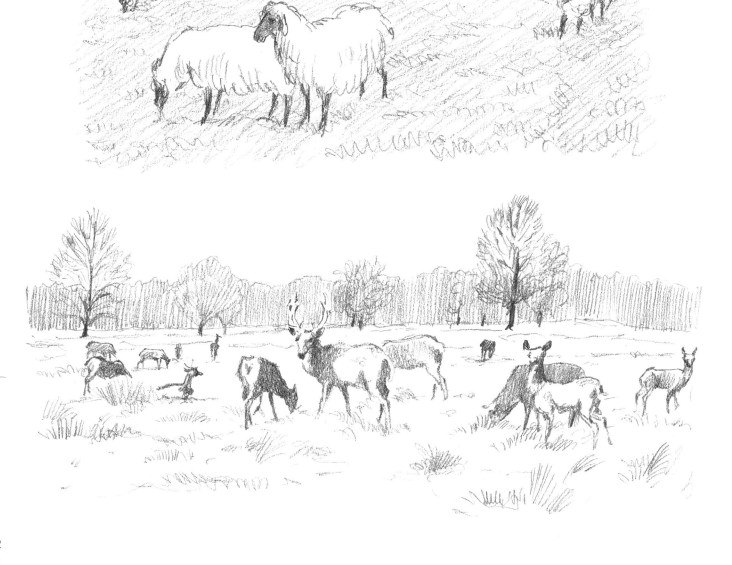

Week 6

Portraits and figures

The human face is often the most attractive subject for an artist. In a way, producing a good portrait of another human being proves to yourself how well you are progressing; it's the hardest area in which your skills will be tested, because everyone can see at once whether you have attained a resemblance to the individual or not.

However, that isn't the be all and end all of a portrait – it's also meant to be a work of art, not just an accurate record of someone's features. In this chapter you'll learn about drawing portraits in a way that will enable you to capture likenesses of your friends and family as well as producing pictures that stand up as art in their own right.

You may often want to make a whole figure study, rather than concentrating entirely on the face, so we shall be taking a look at the proportions of the body and also how to compose pictures with groups of figures in them. Making successful group studies depends not only on catching the likeness of the subjects involved, but also posing them in a way that makes for a successful composition.

You need to find models for this genre, and while you gain confidence it's best to choose people who will be patient and encouraging. One model who is always available, of course, is yourself – many artists have made significant self-portraits, so set yourself up in front of a mirror and see what you can do.

Proportions of the human figure

Generally, the female body is slightly smaller and finer in structure than that of a male, but of course sizes differ so much that you will have to use your powers of observation when drawing any individual. In the examples below, the man's shoulders are wider than the woman's and the woman's hips are wider than the man's. This is, however, a classic proportion, and in real life people are often less perfectly formed. Nonetheless, this is a good basic guide to the shape and proportion of the human body.

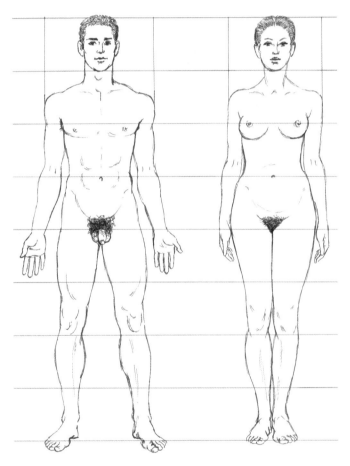

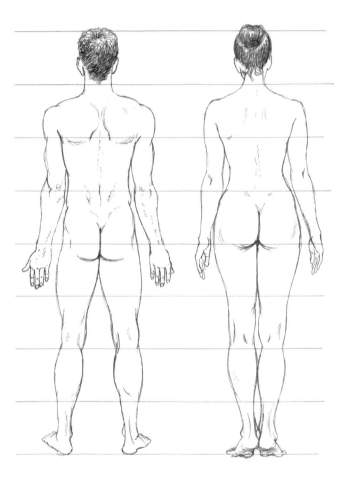

These drawings assume the male and female are both exactly the same height, with both sexes having a height of eight times the length of their head. Note where the other units of head length are placed: the second unit is at the armpits, the third is at the navel, the fourth at the groin or pubis, the fifth mid-thigh, the sixth below the knee joint and the seventh just below the calf. This is a very useful scale to help you get started.

The man's neck is thicker in relation to his head while the female neck is more slender. The female waist is narrower than the man's and the general effect of the female figure is smoother and softer than the man's more hard-looking frame. In the main the differences are connected with childbirth and child rearing; women's hips are broader than men's for this reason too.

Proportions of children

The proportions of children's bodies change very rapidly and because they grow at very different speeds what is true of one child at a certain age may not be true of another. Consequently, the drawings here can only give an average guide to children's changes in proportion as they get older. The child's head is much smaller than an adult's and only achieves adult size at around 16 years old. The most obvious difference between a child, an adolescent and an adult is that the limbs and body become more slender as part of the growing process. In some types, the tendency towards puppy fat makes them look softer and rounder. Boys and girls often look similar until they reach puberty.

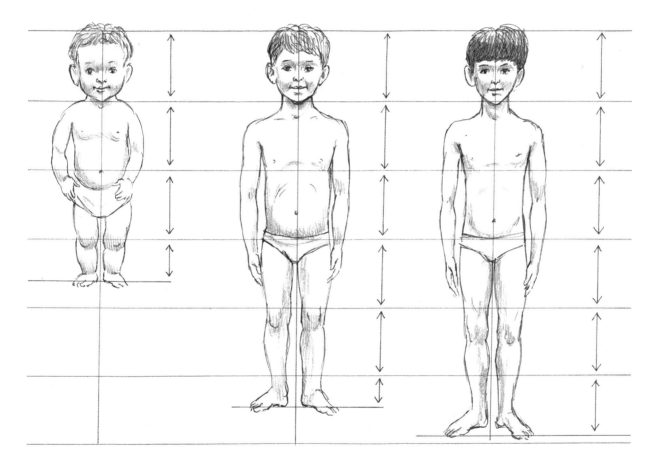

At the beginning of life the head is much larger in proportion to the rest of the body than it will be later on. The child on the left is about 18 months old and shows the proportion you might find in a child of average growth. The height is only three and a half times the length of the head, which means that the proportions of the arms and legs are much smaller in comparison to those of an adult.

At the age of about six or seven, as shown in the drawing in the middle, a child's height is a little over five times the length of the head, though again this is variable. At about 12 years (right), the proportion is about six times the head size. Notice how in the younger children the halfway point in the height of the body is much closer to the navel, but this gradually lowers until it reaches the adult proportion. The relative width of the body and limbs in relation to the height gradually becomes slimmer so that a very small child looks very chubby and round, whereas a 12-year-old can look extremely slim for their height.

Proportions of the head

For beginners especially it can be helpful to use a grid as a guide on which to map out the head, to ensure that the proportions are correct. Those shown here are broadly true of all adult humans from any part of the world, and so can be applied to anyone you care to use as a model. The head must be straight and upright, either full face or in profile, otherwise the proportions will distort.

For these two examples, a proportion of five units across and seven units down has been used. Note the central line drawn vertically down the length of the face – this passes at equidistance between the eyes, and centrally through the nose, mouth and chin.

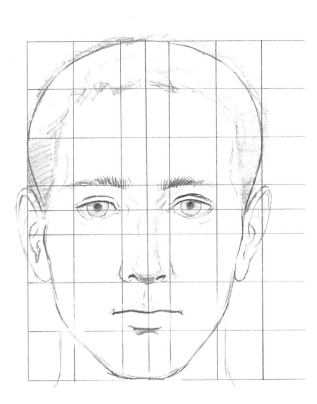

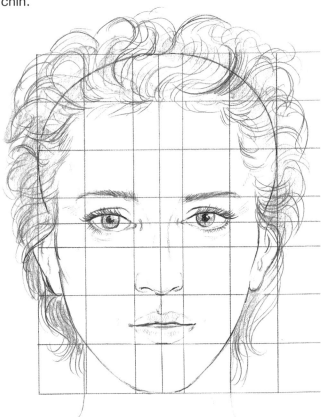

Horizontal Reading: Full Face
- The width of the eye is one-fifth of the width of the whole head and is equal to 1 unit.
- The space between the eyes is 1 unit.
- The edge of the head to the outside corner of the eye is 1 unit.
- The outside corner of the eye to the inside corner of the eye is 1 unit.
- The inside corner of the left eye to the inside corner of the right eye is 1 unit.

Vertical Reading: Full Face
- Eyes: halfway down the length of the head.
- Hairline: 1 unit from the top of the head.
- Nose: 1½ units from the level of the eyes downwards.
- Bottom of the lower lip: 1 unit up from the edge of the jawbone.
- Ears: the length of the nose, plus the distance from the eye-line to the eyebrows is 2 units.

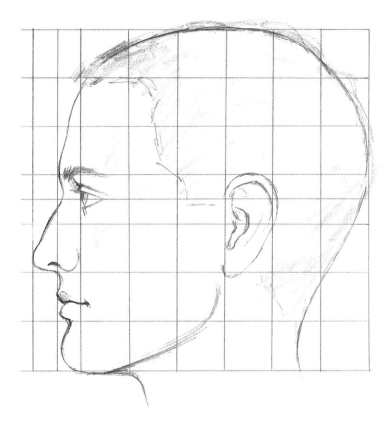

For easy comparison, these two profile examples have been drawn to exactly the same size as those on the preceding page. The head in profile is 7 units wide and 7 units long, including the nose.

Don't forget that the human head is different in each individual. These grids will help you to look at the distances between features, but it is your observational skills that will be needed to create a likeness.

Horizontal Reading: Profile

- The front edge of the eye is 1 unit back from the point of the nose.
- The ear is 1 unit in width. Its front edge is 4 units from the point of the nose and 3 units from the back edge of the head.
- The nose projects half a unit from the front of the main skull shape.

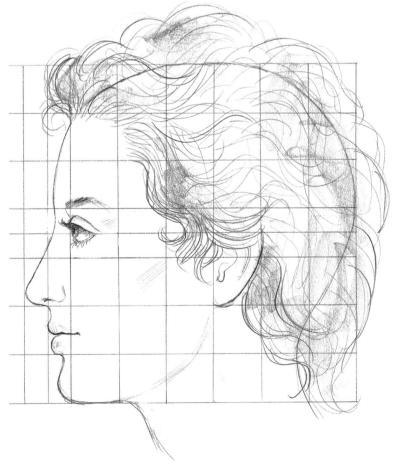

Drawing the features in detail

Before you embark upon drawing a whole portrait, you need to study each of the features and make detailed drawings of them.

I started here by drawing just one eye. This is a difficult thing to do, as the model will find your concentrated stare a little daunting. However, it's also very revealing as to how carefully you have observed the eye. Having drawn my model's eye directly facing me, I then drew it from a slight angle so that I got a side view of it. I did this with both eyes, then drew them as a pair to see how they looked together, as well as the space between them.

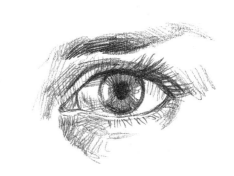

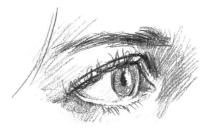

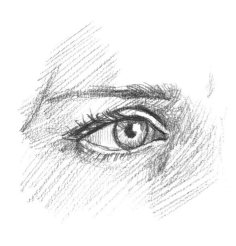

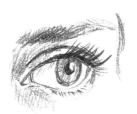

Next I moved on to the mouth and drew it two or three times, exploring the front, side and three-quarter view.

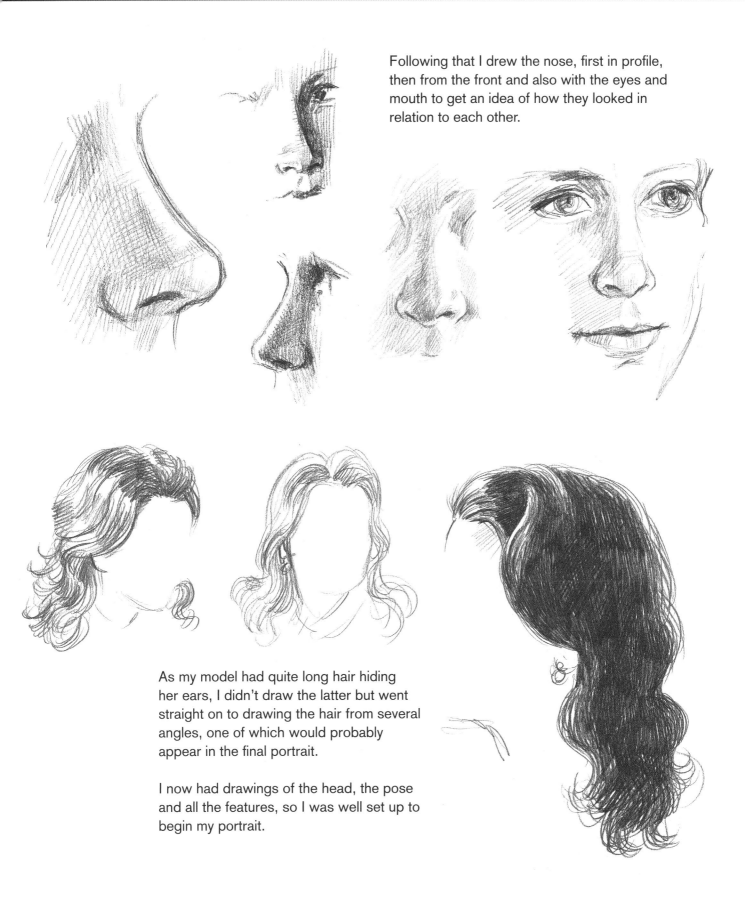

Following that I drew the nose, first in profile, then from the front and also with the eyes and mouth to get an idea of how they looked in relation to each other.

As my model had quite long hair hiding her ears, I didn't draw the latter but went straight on to drawing the hair from several angles, one of which would probably appear in the final portrait.

I now had drawings of the head, the pose and all the features, so I was well set up to begin my portrait.

Drawing your family

Now let's look at what happens when we choose our nearest and dearest for our portrait sitters. Most of us have enough family and friends to practise our drawing skills on, and it is of great benefit to draw the people you have easiest access to and whom you know very well. This in-depth knowledge can help to give your portraits more power.

I decided to have a go at drawing most of the members of my family who were in the house one Christmas, and I started with my grandchildren. Of course young children and babies will not sit still for you much so this is probably an occasion when photography can come to your aid. It does help to have the originals around as well, though, because this helps to inform your drawings from photographs that you have taken yourself.

Here is my youngest grandson, caught in his mother's arms and laughing at the camera. As you can see, his round, open eyes and nose and mouth are all set neatly in the centre of the rounded form of his head and face.

Next my granddaughter lounging on the floor, kicking her legs and giggling. Here, I concentrated on her gleeful expression.

I drew my youngest daughter while she was talking to someone else, so almost unaware of me.

My eldest grandson, looking a bit shy but amused. He couldn't stay still for long, so I took a photograph just before I started drawing.

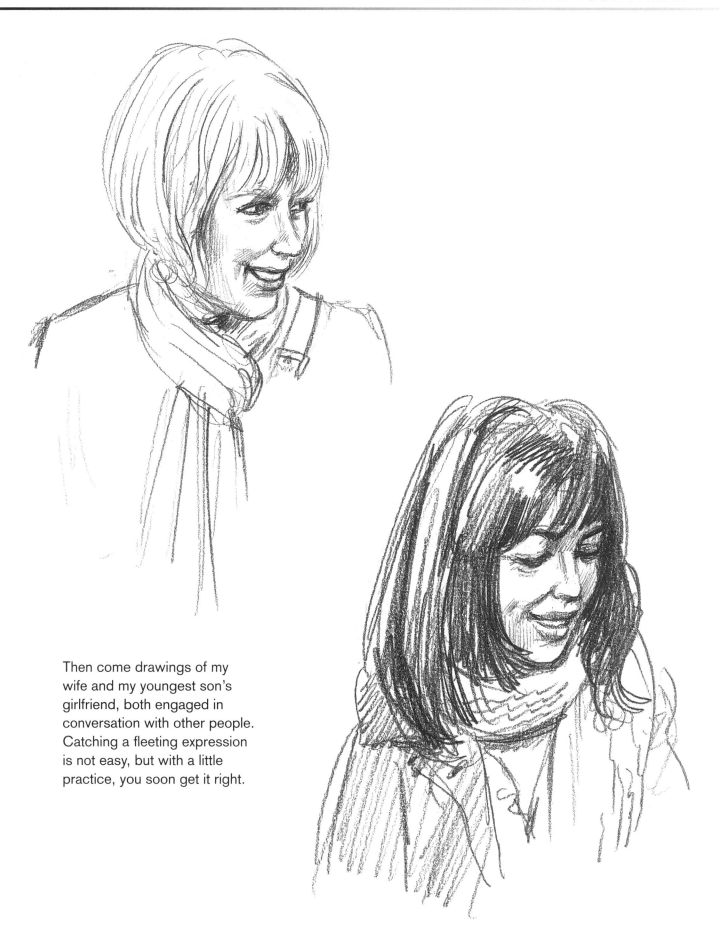

Then come drawings of my wife and my youngest son's girlfriend, both engaged in conversation with other people. Catching a fleeting expression is not easy, but with a little practice, you soon get it right.

A portrait project

This exercise entails quite a bit of drawing and you will learn a lot about your model's appearance by spending whole sessions drawing and redrawing him or her from as many different angles as you think would be useful.

Sketches of the head

I had as my sitter a young girl who has posed for me before as a portrait model. Models do get bored with sitting still for too long, so you have to be as quick as you can, or try to keep them amused in some way.

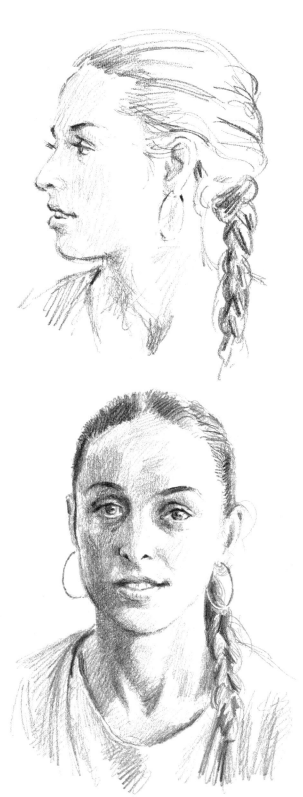

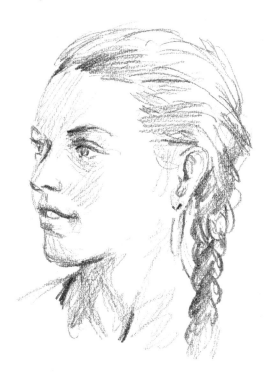

I began by working my way round my sitter's head, drawing her first from the side or profile view, then from a more three-quarters view and finally full face. These studies gave me a good idea as to the physiognomy of her face.

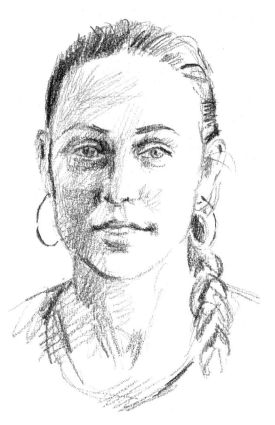

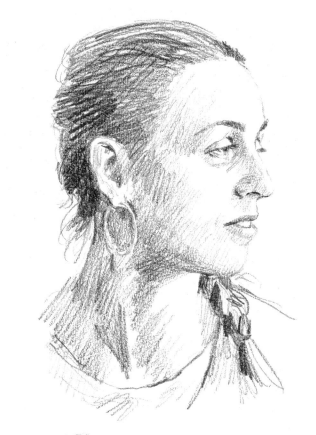

Next I tried her full face with quite a lot of light on her face, then almost in profile in the same light.

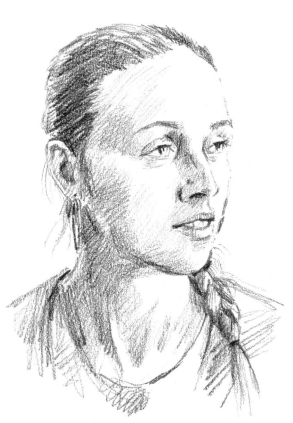

I had a go at drawing her with most of her face in shadow, then with her face half brightly lit and half darker.

Sketching different poses

Now you need to spend some time drawing the sitter in different positions, using a full-length or three-quarter length pose.

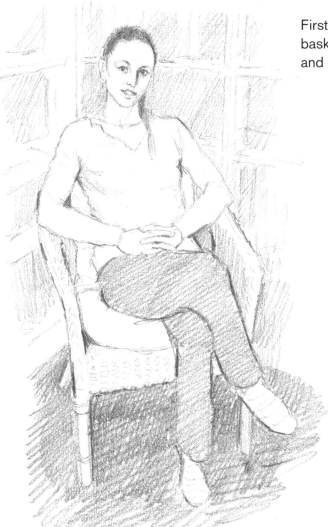

First I drew my model sitting in a small basketwork chair with her legs crossed and her hands in her lap.

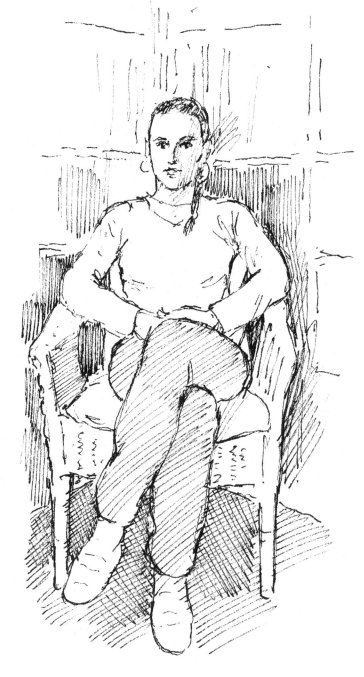

Next I tried her with her legs crossed the other way round.

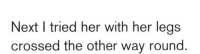

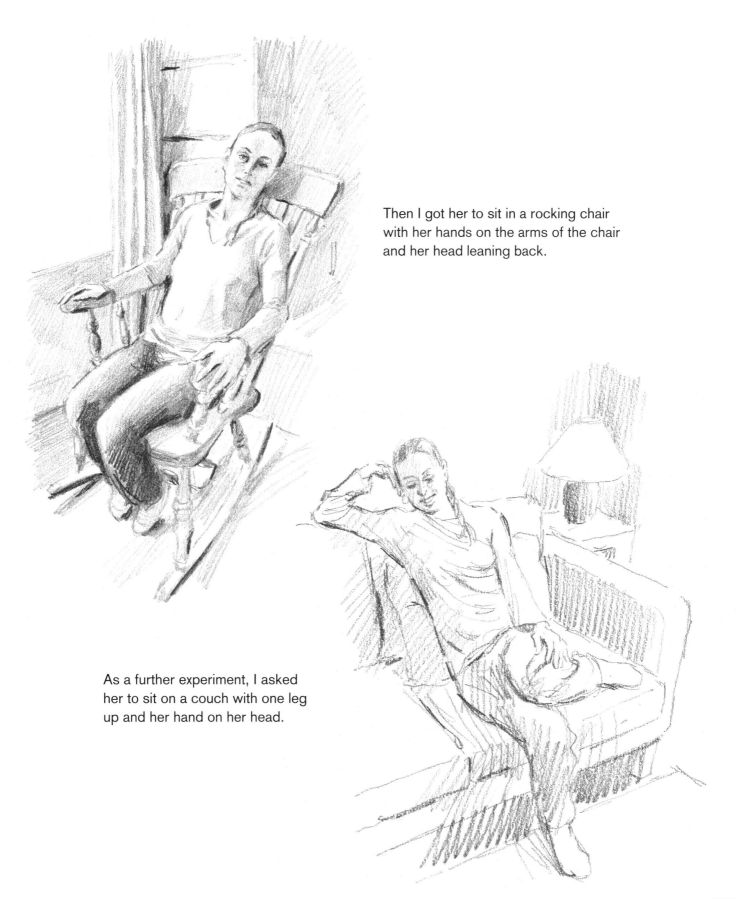

Then I got her to sit in a rocking chair with her hands on the arms of the chair and her head leaning back.

As a further experiment, I asked her to sit on a couch with one leg up and her hand on her head.

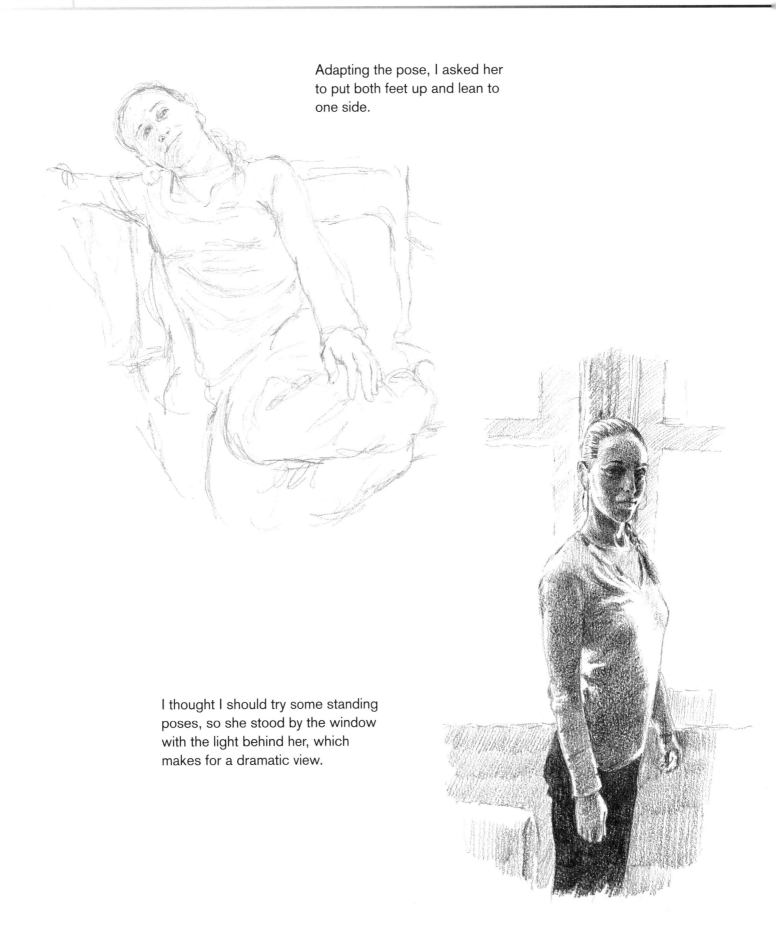

Adapting the pose, I asked her to put both feet up and lean to one side.

I thought I should try some standing poses, so she stood by the window with the light behind her, which makes for a dramatic view.

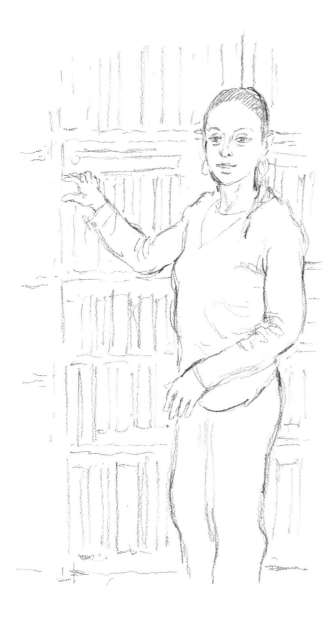

Then I asked her to stand by a bookcase with her hand on the shelf, but decided I didn't want to continue any further with that pose.

Finally, I tried placing her in a very relaxed pose, seated in an armchair with her ankles crossed.

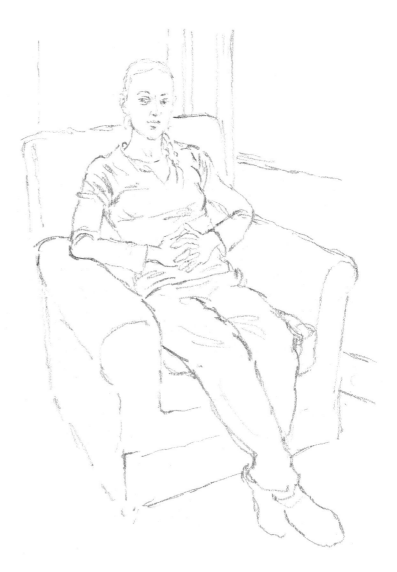

Choose your composition

With my drawings gathered together, and my model refreshed and ready to sit again, I first had to choose the pose and then draw it as simply as possible, but with all the information I needed to proceed with the finished portrait. I decided I wanted her sitting with her feet up on the couch hugging her knees, almost in profile. The light was from the right-hand side from a large window, and was full on her face.

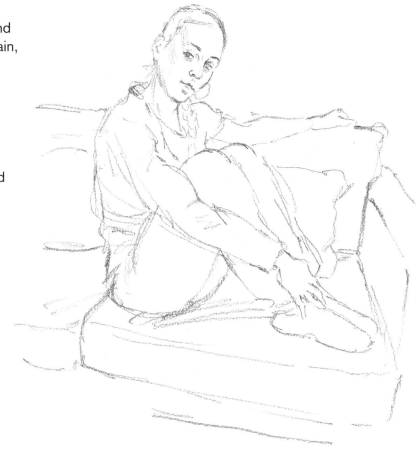

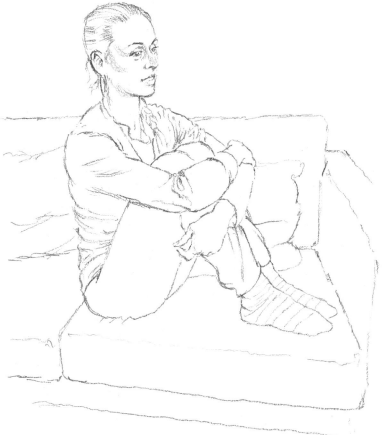

I then spent time drawing her in some detail, but without shading, to create a cartoon to work from. I tried to be as accurate as I could, so that the cartoon would inform me when I did the final piece of work. This is a useful thing to do, as it allows you to make mistakes and correct them before you start on your final piece, by which time you should know exactly what to do.

Step 1

First I drew a quick sketch that told me where everything would be placed. This looked like a simpler drawing of my cartoon, which I had nearby for reference.

Step 2

Then, still using my cartoon as a guide, I drew up a careful outline drawing of the whole figure and the background setting in some detail. This was the last stage at which I could introduce any changes if they were necessary.

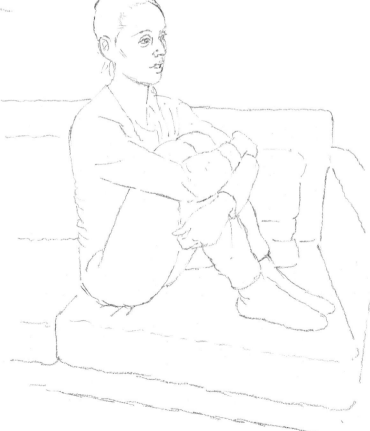

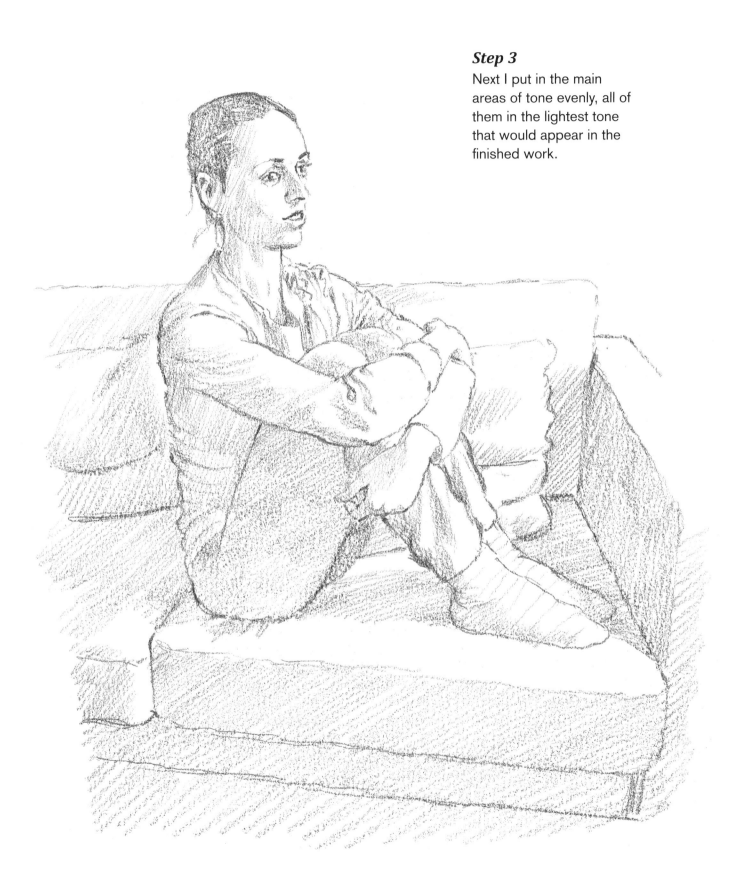

Step 3
Next I put in the main areas of tone evenly, all of them in the lightest tone that would appear in the finished work.

Step 4

Now I could build up all the different tones until I had produced a convincing three-dimensional portrait that looked like the sitter. This is quite a long process, but it is worth taking the trouble, because the chances are that both you and the sitter will be pleased with the result.

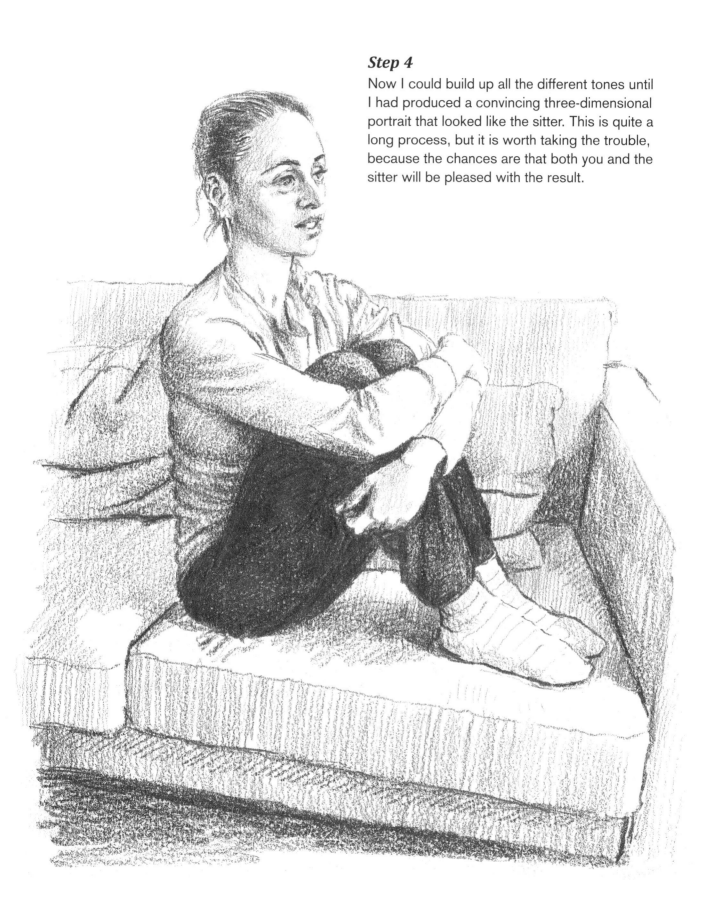

Preparing a group portrait

Portrait drawing is different from other genres in that there's a need to capture likenesses of the people concerned – and while most people are happy with a flattering portrait they often don't like a drawing that doesn't fit with how they see themselves. In other words, your freedom for artistic licence is more limited than in, say, landscapes, but will be allowed as long as it's in the sitter's favour!

So, when it comes to drawing a group of people, the task in hand is to make sure that all the faces of the individuals are recognizable enough to satisfy their inspection. It's a good idea to get some photographic reference as well to ensure that you have got all the necessary information, taking shots of each face from different angles and also the whole composition. Draw sketches of each person and the composition to give yourself plenty of reference material that will work as back-up if you need to halt the proceedings at any time and return to them later – especially with a large group, who may not all be able to reassemble.

Small groups

In this portrait context, 'group' means anything other than one person. The group you will most often be asked to draw is just two people, usually with a close relationship with each other.

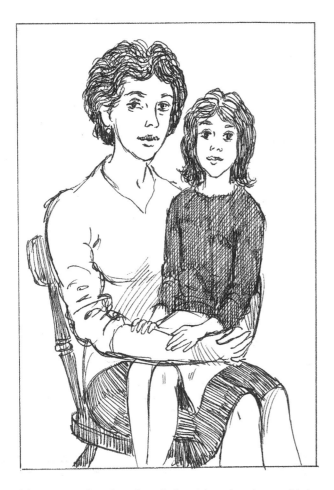

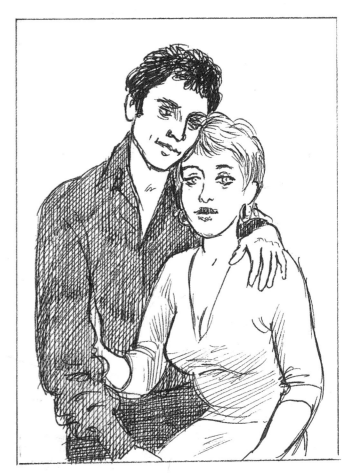

Here a mother has her little girl on her lap, which creates a good tight composition. As long as the child will stay still for long enough there's no real problem with such a drawing. Once you have sketched in the main shapes of the two figures you can draw the child first as quickly as possible, then when he or she wants to move you can concentrate on the mother.

The second type of group, probably lovers or a married couple, is a bit more tricky because you will want a close connection between the two people but they may find it difficult to sit as close as this pair for any length of time. Entwined figures do make for a good composition, but you may have to work more quickly than you would wish.

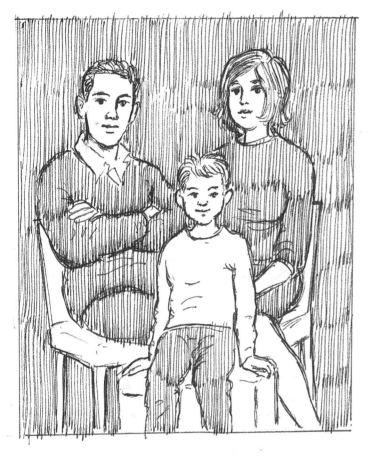

The next group has progressed to three people. The first trio is the obvious one of a couple and their child. The two adults sit next to each other and the child is in the centre of the composition, linking the two larger figures.

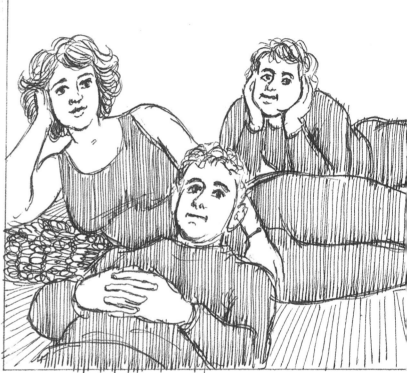

The second trio is two brothers and their sister, arranged in a much less formal composition than those shown so far. This isn't usually difficult with siblings under a certain age because of the sort of relationship they tend to have with each other. They probably won't mind a less conventional pose because they'll treat it as a sort of game.

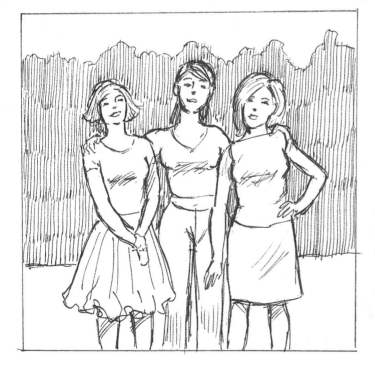

The last of these groups (left) is of three female friends, who are drawn as though interrupted out on a jaunt. Posed against a backdrop of trees, they might have been caught on camera as they were on a day out in the country.

Larger groups

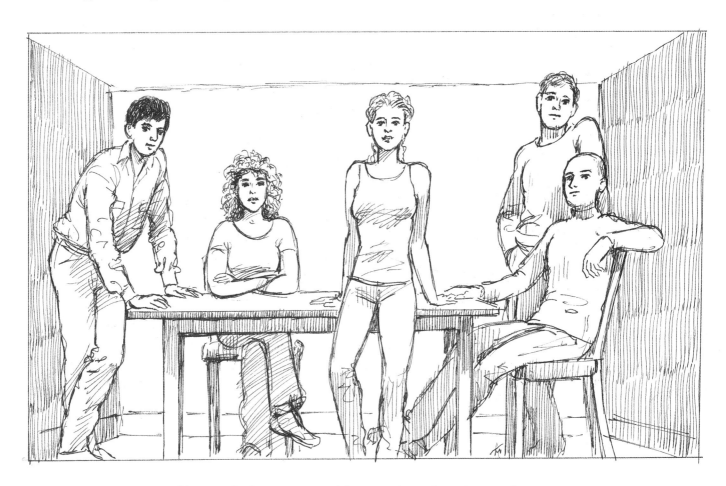

Now we look at a group of five people gathered around a table, which acts as a sort of support structure. With two sitting and three standing you get a certain dynamic in the composition which creates interest. It's also easier to make an interesting group with an uneven rather than even number of people. One of the standing figures is leaning on the back of the chair of the seated figure at one end while another leans on the table at the opposite end. The central figure also leans back on the table, but being female she is not too bulky for the central role. The two seated figures, male and female, help to create a more horizontal shape to the arrangement.

Here's another group of five people, but this time out in the garden, obviously in summer. The arrangement isn't as limited as the interior scene because there's more depth of space in which the figures can be placed. The main thing is to be able to arrange them so that the group looks natural. I have opted for one young man standing with his hands in his pockets to one side of the composition, and an older man on the far side reclining in a deck chair with a book on his lap. These two enclose the others neatly. The other seated figure of a woman is opposed in arrangement to the seated man, their legs overlapping from our viewpoint. In the centre, but much further back, are a young man pushing a lawnmower and another man seated on the grass behind the woman so that only his head and shoulders show. The background of the conservatory, bushes and trees gives more sensation of depth in the composition.

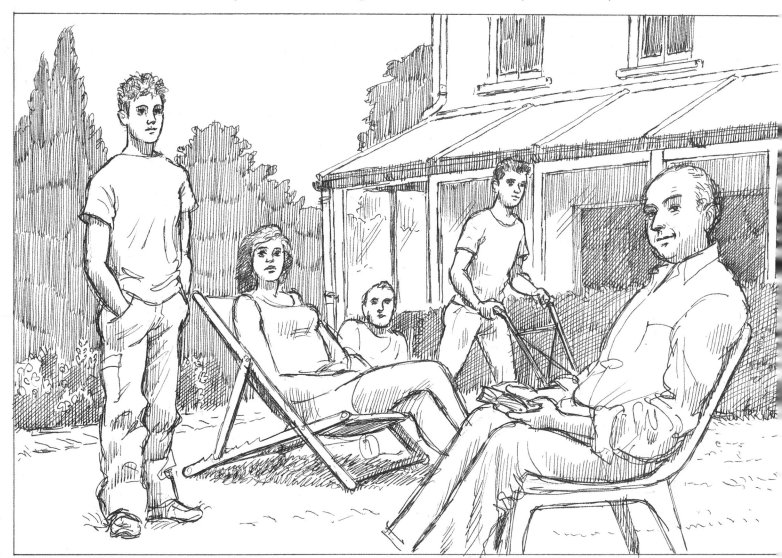

A self-portrait

At some time or another all artists have a go at a self-portrait or two, it being the simplest way to obtain a sitter. All you need to do is grab a sketchbook or a board and paper, sit down in front of a good-sized mirror and draw away.

Another reason why artists draw many self-portraits is that you don't have to worry about anybody else's opinion of the result; you can be as objective as possible about the drawing and you won't be offended if the likeness is neither perfect nor flattering.

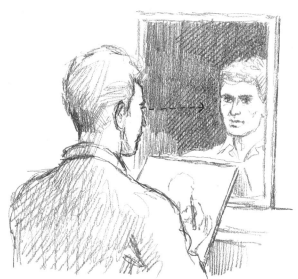

A feature of the self-portrait is that you'll tend to be looking at your full-face image, and the only real variation on this is to turn your head a little to the left or right and glance at yourself from the corner of your eye. This will give you a three-quarter view of your face but your eyes will still be looking straight at you. To avoid this you'll need to get indirect views of your own head by using two mirrors at an angle to each other, but this is a rather complicated way to work.

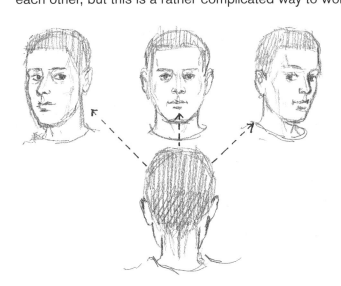

The other alternative is to take a photograph of yourself and work from that, but when you are drawing the final piece, refer back to a mirror image because you will see much more information there than the photograph will give you.

Master examples

The best way to learn is to study what the experts have done, and you'll find looking at self-portraits useful when you're engaging with your own. Here, although the angle of the face to the viewer is quite similar, the portraits have a very different mood. Making a self-portrait is not just about recording your features; it should also convey something about how you see yourself.

This picture after a self-portrait by Robert Bevan (1865–1925), done just before the First World War, is a beautifully understated piece of work which gets across the look of the artist very directly. He has reduced all modelling and form to the minimum but still gives enough information to show depth and dimension.

This self-portrait made by the great British Impressionist Walter Sickert in 1896 is a dark study with his face appearing from the gloom. He has kept the handling of the form very simple, and the way a ray of light has revealed the side of the face is quite dramatic.

Making my own self-portrait

So now I shall show the stages of a self-portrait that I attempted while in my garden studio. The light is behind me so that my face is in shadow, and as I was wearing a white shirt at the time there's a big contrast between the area of skin and the area of cotton shirt. The glasses emphasize the stare of the eyes which is endemic in most self-portraits.

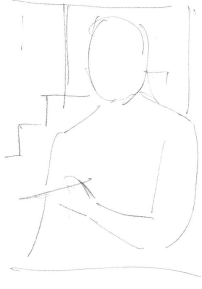

Step 1

I started by just blocking in a simple shape that gave me the proportions of the head and body. This is well worth doing, because it's easy to lose the proportion when you get into the detail.

Step 2

Then I began to describe more carefully an outline of the main shapes and form, which I drew lightly so that I could easily correct mistakes. This is the stage when any erasing is done, so take your time about this part in your own self-portrait.

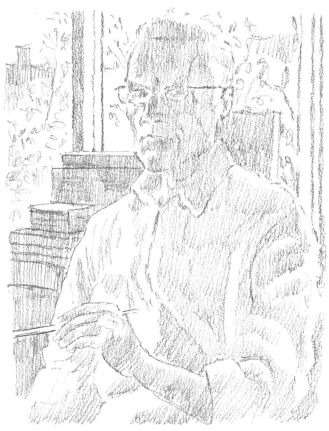

Step 3

Next I put in the tonal area, keeping the tone the same all over the picture. This is important, because it's easy to get tones wrong if you start putting them in heavily straight away.

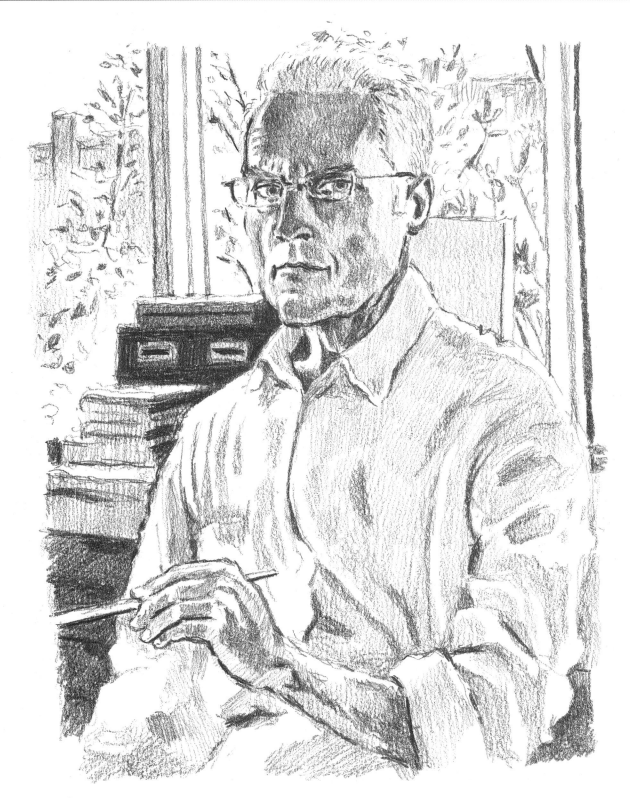

Step 4

The last stage was to build up my tonal values so that the picture started to look solid, with the effect of the light falling on the edge of the face and the shirt folds. The tone of the objects just behind my shoulder was useful to bring my figure forward in the picture. This is a very straightforward, naturalistic drawing, but that's my own style – and fortunately it makes for an easier demonstration of how to do a self-portrait.